THE BLUE BOOK

COLOURWORKS

THE
BLUE
BOOK

DALE RUSSELL

PHAIDON · OXFORD

A QUARTO BOOK

Published by
Phaidon Press Limited
Summertown Pavilion
Middle Way
Oxford OX2 7LG

ISBN 0 7148 2712 6
ISBN 0 7148 2716 9 (boxed set of five in series)

First published 1991
Copyright © 1991
Quarto Publishing plc

A CIP catalogue record for this book is available from the British Library

This book was designed and produced by
Quarto Publishing plc
The Old Brewery, 6 Blundell Street
London N7 9BH

SENIOR EDITOR: Sally MacEachern
EDITOR: Paula Borthwick
DESIGNERS: Penny Dawes, David Kemp, Julia King
PICTURE MANAGER: Joanna Wiese
PICTURE RESEARCH ADMINISTRATION: Prue Reilly, Elizabeth Roberts
PHOTOGRAPHERS: Martin Norris, Phil Starling

ART DIRECTOR: Moira Clinch

Manufactured in Hong Kong by Regent Publishing Services Ltd
Typeset by Bookworm Typesetting, Manchester
Printed in Singapore by Tien Wah Press (Pte) Ltd

DEDICATION
With great love, I would like to thank my husband Steve for patiently guiding me through
the days and nights overtaken by colour and my daughter Lucy Scarlett for remaining
happy while colour came first.

The colour tints printed in this book have been checked and are, to the publisher's knowledge,
correct. The publisher can take no responsibility for errors that might have occurred.

CONTENTS

THE COLOURS

22

Using Colourworks

To make the most of the *Colourworks* series it is worthwhile spending some time reading this and the next few pages. *Colourworks* is designed to stimulate a creative use of colour. The books do not dictate how colour should be applied, but offer advice on how it may be used effectively, giving examples to help generate new ideas. It is essential to remember that *Colourworks* uses the four-colour process and that none of the colours or effects use special brand name inks.

The reference system consists of five books that show 125 colours, with 400 type possibilities, 1,000 halftone options, and 1,500 combinations of colour. But even this vast selection should act only as a springboard; the permutations within the books are endless. Use the books as a starting point and experiment!

When choosing colours for graphic design it is almost impossible to predict the finished printed effect. In order to save valuable time spent researching, you can use the series' extensive range of colours to provide references for the shade with which you are working.

The four process colours

Yellow Magenta Cyan Black

▲ Enlarged detail showing how four process colours overlap to produce "realistic" colour.

▼ This page is a visual reference to the colours shown in this book giving the page numbers where the colour is featured, and the colour tint specification.

THE COLOURS

Colour contents page 22

▼ This page shows exactly the same colours, but here they are printed as if on various tinted stock papers. Sometimes the result is dramatic; other times it is negligible.

Tinted stock page 24

▼ Constant colour charts: The 25 main colours are each set against 56 constant colours. Once you have selected your main colour – perhaps the corporate colour of your client – this spread will act as a reference for choosing a secondary colour. The constant colour charts will show whether this specific colour will project, recede, harmonize or clash.

Constant colour charts

The books are ideal for showing to clients who are not used to working with colour, so that they may see possible results. They will be particularly useful when working with a specific colour, perhaps dictated by a client's company logo, to see how this will combine with other colours. Equally, when working with several colours dictated by circumstances – and perhaps with combinations one is not happy using – you will find that the constant colour charts, colourways and applications will show a variety of interesting solutions. The numerous examples in *Colourworks* can act as a catalyst, enabling you to break out of a mental block – a common problem for designers who may feel that they are using a wide variety of colours but actually be working with a small, tight palette. Finally, when faced with a direct colour choice, you should use *Colourworks* in the same way you would use any other art aid – to help create the final image. The books are designed to administer a shot of adrenaline to the design process. They should be treated as a tool and used as a source of both information and inspiration.

TERMINOLOGY USED IN COLOURWORKS

Main colour: one of the 25 colours featured in each book.

Colourway: The main colour plus two other colour combinations.

Constant colour: The main colour with 56 constant colours.

Y: yellow
M: magenta
C: cyan
Blk: black
H/T: halftone
F/T: flat-tone

TECHNICAL INFORMATION

When using *Colourworks* or any colour specification book, remember that paper stock, lamination and type of ink can change the effect of chosen colours. Coated papers, high-quality especially, tend to brighten colours as the ink rests on the surface and the chalk adds extra luminosity, while colours on uncoated paper are absorbed and made duller. Lamination has the effect of making the colour darker and richer.

Colourworks specification

Colour bar GRETAG
Screen 150L/IN
Film spec.: AGFA511P
Tolerance level: +2% − 2%
Col. density: C=1.6−1.7
　　　　　　　M=1.4−1.5
　　　　　　　Y=1.3−1.4
　　　　　　　Blk=1.7−1.8
Ink: Proas
Paper: 130gsm matt coated art
Plate spec.: Polychrome
Dot gain: 10%
Printed on Heidelberg Speedmaster 102v
Printing sequence: Black/Cyan/Magenta/Yellow

▼ Colourways: This spread shows options for gradated tones, four text variations, eight halftone effects and suggested colour combinations. For specific information see pages 8 and 9.

▼ Applications: A cross section of design ideas showing classic, innovative and emotive use of the specific colour. These images were chosen because the specific colour told the story.

Colourways

Applications

On the next four pages you can see, in step-by-step form, exactly how to understand and use the colour reference system shown in *Colourworks* and how you can incorporate the ideas into your designs.

It is essential to remember that *Colourworks* uses the four-colour process – none of the effects uses the special brand name ink systems – usually described as "second colours".

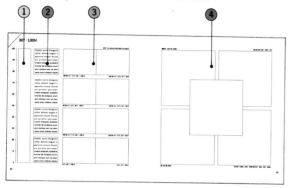

1. GRADATED COLOUR

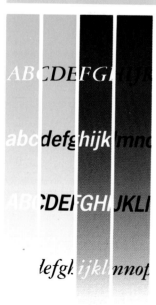

The colour scale shows the main colour fading from full strength to white. If you are using a gradated background, the scale clearly demonstrates at what point reversed-out-type would become illegible – with a dark colour you may be able to reverse out down to 20% strength, with a pastel only down to 80% or perhaps not at all, in which case the type should be produced in a dark colour.

The opposite would be true if the design incorporated dark type on a fading dark colour. Again, unless a very subtle result is required, the scale indicates at what point type would become illegible.

The other use of the fade gives the designer more colour options – perhaps you like the colour on page 102, but wish it was slightly paler. With the gradated shading you can visualize just how much paler it could be.

2. TYPE OPTIONS

The main colour with different type options: solid with white reversed out; type printing in the colour; black and the type reversed out as colour; solid with black type. These examples demonstrate the problems of size and tonal values of the type.

The type block is made up of two typefaces, a serif and sans serif, both set in two different sizes.

9pt New Baskerville

7pt New Baskerville

Ossidet sterio binignuis

gignuntisin stinuand. Flourida

trutent artsquati, quiateire

semi uitantque tueri; sol etiam

8½pt Univers 55 7pt Univers 55

Size

Using the four-colour process the designer obviously has no problems choosing any combination of tints when using large type, but how small can a specific colour type be before it starts to break up or registration becomes a problem? The type block shows when the chosen tints work successfully and more important *when they do not*.

Ossidet sterio binignuis tultia, dolorat isogult it

9pt New Baskerville: 70% Cyan demonstrates no problems.

gignuntisin stinuand. Flourida prat gereafiunt quaecumque

7pt New Baskerville 50%Y 30%M 100%C the serifs start to disappear.

Tonal values

Obviously, when dealing with middle ranges of colour, printing the type black or reversed out presents no legibility problems. But the critical decisions are where the chosen colours and shade of type are close. Will black type read on dark green? Will white type reverse out of pale pink? When marking up colour, it is always easier to play safe, but using the information in *Colourworks* you will be able to take more risks.

Ossidet sterio binignuis tultia, dolorat isogult it

Ossidet sterio binignuis tultia, dolorat isogult it

The problem is shown clearly above: using a pastel colour (top) it would be inadvisable to reverse-out type; with a middle shade (centre) the designer can either reverse out or print in a dark colour; while using a dark colour (bottom), printing type in black would be illegible (or very subtle).

3. HALFTONE OPTIONS

This section demonstrates some possibilities of adding colour to black and white halftones where the normal, "realistic" four-colour reproduction is not desired or when the originals are black and white prints. This section gives the designer 800 options using various percentages and combinations of the process colours.

100% main colour **50% strength of main colour**

100% black H/T plus full strength of the main colour

100% black H/T plus 50% of the main colour

50% black H/T plus full strength of the main colour

50% black H/T plus 50% of the main colour

100% black H/T plus a *flat* tint of the main colour at full strength

100% black H/T plus a *flat* tint of the main colour at half strength

H/T using only the main colour at full strength

H/T using only the main colour at half strength

Moiré pattern

Some of the main colours in this book include percentages of black. If this film is combined with the black film from the halftone a moiré pattern can occur. To overcome this possibility the films for *Colourworks* have been prepared in two ways. When the main colour is made up of 3 colours of less, e.g. p98, the two black films have been specially angled. When the main colour is made up of four colours plus the extra black (p140 only) it is impossible to create an extra screen angle. In order to give the effect of the extra black, the repro house has strengthened the black H/T dot in the mid tones and highlights by the appropriate percentage. However, moiré pattern will occur on the flat tint section. Discuss this with your repro house if you want to use B/W halftones with these few colours.

4. COLOURWAYS

This page shows the main colour with other colours. It acts as a guide to help the designer choose effective colour for typography and imagery. Each colour is shown as four colourways; each colourway shows the main colour with two others.

The three colours in each colourway (corner) are in almost equal proportions. The effect would change dramatically if one colour was only a rule or small area. Use the colourways to find the appropriate range for your design and adapt it accordingly.

For information on using the central square and its use in commissioning photography or illustration see page 10.

The choice of colour has not been limited to the safe options. The easy neutrals cream, white and grey have been used, but so have more unusual combinations.

The colours show various effects; look at each corner, if necessary isolating areas.

▼ Colours are shown projecting forwards sometimes using the laws of optics which say that darker, cooler shades recede.

▲ Sometimes, due to the proportions, defying them.

▲ These are classic colour combinations.

▲ Colours that are similar in shade.

abcdefghi

▲ Use these colours for background patterns, illustrations or typographic designs where the colour emphasis has to be equal.

abcdefgh

▲ These colours are not advisable if your design needs to highlight a message.

Analyse your design to see how dominant the typography, illustrations, and embellishments need to be versus the background, then use the colourways to pick the appropriate colours or shades.

When selecting colours, it is very important to eliminate any other colour elements that might affect your choice. As has been demonstrated in the colour optics section (p.14), the character of a colour can be dramatically changed by other, adjacent colours.

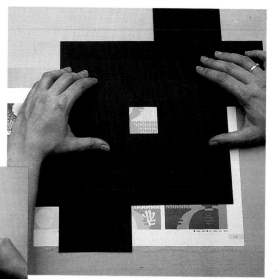

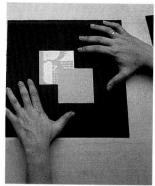

◀ ▲ The colourways have been designed in such a way that you can mask out the other colour options – isolating the area you want to work with or even small sections of each design.

▼ ▶ The colourways can also be used if you are selecting the colour of typography to match/enhance a photograph or illustration; again masking out the other colourways will help. A print of the photograph or illustration can be positioned in the central area, and the mask moved around.

Useful mask shapes

The design shown on this page was created to demonstrate the practical use of *Colourworks*. It combines many halftone effects and colour combinations.

The options illustrated are drawn from *The Blue Book*. For more suggestions and further inspiration, refer to the other books in the series.

► Using elements from
The Blue Book pages
134-35, 136-37.

◄ Using elements from
The Blue Book pages
64-65, 66-67.

Blue introduction

" *Any group of colours, such as that of a clear, unclouded sky, that have wavelengths in the range 490-445 nanometers. Blue is the complementary colour of yellow and with red and green forms a set of primary colours.* **"**

Collins English Dictionary; Publishers William Collins Sons and Co. Ltd., London and Glasgow; Second Edition 1986

" *A colour whose hue is that of the clear sky or that of the portion of the colour spectrum lying between green and violet.* **"**

Webster's Ninth New Collegiate Dictionary, Merriam-Webster Inc., Publishers, Springfield, Massachusetts, U.S.A. 1983

Colour is not tangible; it is as fluid as a musical note. Although it may be described, the verbal or written words often bear no relation to its actual form. Colour has to be seen in context, for a single shade used in conjunction with another colour can take on a whole new character. Searching for a particular shade can be very confusing – somewhat like humming a tune and searching for a forgotten note.

No matter how much theory exists, it is the eye of the designer or artist that is responsible for using colour creatively. The fact that colour can be rationalized and then break its own rules with complete irrationality is what makes it so fascinating.

This book is about process colour. By the very nature of the process system, colours are not blended, as with pigments, but shades are selected visually by percentage. Unlike pigment colours, process colours can be mixed without losing any of their chromas. The process primary colours are magenta, yellow, and cyan, with black to create density and contrast, allowing dot saturation to establish values of lightness and darkness. The pigment primaries are red, blue and yellow.

The concept of process colour is not really new. The German poet and scientist Goethe (1749-1832) looked at effects of light and darkness on pigment colour in a way that strongly relates to modern interpretation of process colour. In complete contrast, a practical approach was taken by the 20th-century German painter Hickethier, who created a precise notation system based on cyan, magenta, and yellow for printing. Between these two extremes lies the concept of the process colour system.

The colours used in these books had to be systematically chosen to prevent *Colourworks* from dating or the colours from being a purely personal choice. It was important to rely on theory and I finally selected over a thousand colours for the five books that make up this series. This meant working with literally thousands of colours, and yet in spite of this comprehensive palette, there would still be a precise shade that would remain elusive.

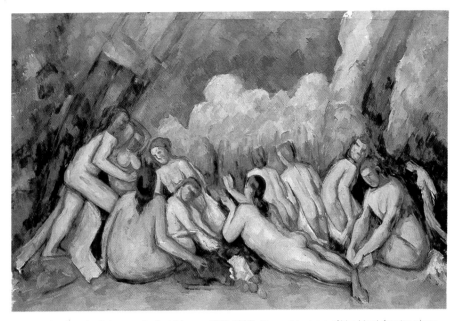

Les Grandes Baigneuses by Paul Cézanne (1839-1906). Harmonizing tones of blue blend, forming shape and movement; the varying intensities of these shades create a sense of dimension. Ochre complements and balances the blue palette, bringing light and warmth.

My next major task was to select each image from advertising agencies, design consultancies, illustrators and actually "off the walls". Every piece of printed matter, label, carrier bag or magazine was a potential gold mine of material for the books. Many images had to be excluded, even though they had superb colouration, because they did not tell a story with one predominant colour.

Colourworks examples had to have immediate impact, with one colour telling the story–whether in harmony with others, through shock tactics, providing a backdrop, creating a period setting, making instant impact for the recognition of the image content, or simply combining superb use of colour with design.

Colour combinations are infinite, and every day wonderful examples of colour and design are being created. Having drawn from just some of these images, I hope that the *Colourworks* series will become a reference to inspire, confirm and enjoy.

Dale Russell

Optical illusion, proportion, and texture

The strength of blue is that it creates the illusion of optically receding, whether used as a background colour or applied to other objects. The main emotional aspect of blue is that it is a cool colour. Because of its ability to recede and calm, it can easily be employed to portray air and space.

This colour loses some of its cool when magenta is introduced; then it takes on a purplish cast. Placed next to a red it becomes a blue-green tone, while the red takes on an orange tone and seems to advance. Combined with yellow, blue acquires a purple tone; the yellow inclines towards orange.

Adding yellow to form turquoise gives blue far greater visibility. A combination of blue and white also has a very strong visibility and impact. Blue makes white appear purer, and in some cases a small percentage of blue overlaid on white can intensify the effect of the pure white.

▲ Planetary eclipse brings life to a static piece of paper. There is continuous movement as the navy gradually covers the planet to total eclipse and then slowly reveals the full-blown, pale yellow planet once again. The soft fade around the planets creates a glowing effect against the navy background.

▲ Clever use of three different percentages of cyan transforms what could have been a highly complex diagram into a graph which can be easily assimilated. The combination of cyan, a pale background, and black typography creates a pristine, efficient image.

▲ ▲ By using the simplest of approaches – a pale green tint applied over a blue background – the designer has produced a subtly pleasing tonal demarcation on the graph but also spotlighted the productive growth.

▲ The interplay between the yellow and cobalt blue is so strong that the red of the matchsticks appears to be lit. The white typography is discreet, in contrast to the interaction between the three main colours.

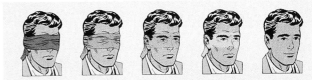

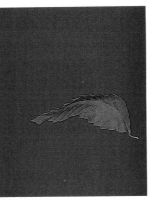

Childsplay

▲ Turquoise is the perfect foil for magenta. It allows the electricity of the magenta to project while retaining its own soft warmth. The area within the cut-out mask becomes a stronger, more vivid green due to the complementary interplay between the magenta and turquoise.

▲ Because hues and intensities are used to create a self-colour pattern within the blue, the appearance is decorative, but in no way breaks from the image of the company. The blue reflects dependability and monetary stability as does the type.

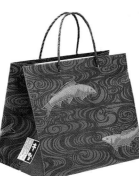

▲▲ The optical illusion is of a leaf floating – an effect created by using blue, a receding colour, as a background. The strong contrast intensifies the clarity of the golden yellow leaf.

▲ Ink blue on steel blue creates the texture of moving water. The grey fish swim through the waves in graceful arcs. The highlights of silver-white on the fishes' backs create the illusion of a sheen. The white on black and black on white typography is striking and, with the white on grey, is sympathetic to the colouration of the fish.

▲ With an extremely clever use of hues and intensities the designer has tonally removed the solid blue mask to make it symbolize enlightenment. The use of medium blue for the original mask and bright yellow for the coat collar accords with the 1950s comic-style drawing.

▲ In this letterhead each name is represented by a star; they in turn have become a constellation; the dark blue of a night sky fades as it approaches the planet Earth which is formed from the name and address. White was the obvious choice for the type as it is visible against the navy, and balances with the white of the paper.

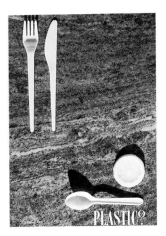

PLASTIC?

▲ A simple white plastic knife, fork and spoon are elevated to the world of natural substances by the juxtaposition of a granite surface. The colouration of the granite, including blue, black and white, not only makes the plastic whiter than white but also creates a visual softness which contrasts with the harsh plastic. The natural yellow of the slice of lemon forms a link between the textured blue granite and the pure white plastic.

Psychology

Blue evokes a multitude of emotive and often contradictory images which can be used to stir the imagination and senses.

The most obvious associations with blue are those of the sky and sea. Differing conditions can give us an entire range of blues, from the deep, clear cobalt of a summer day to the stormy greys and greens of wild, turbulent weather. Yet because the sky and sea are eternal and seemingly infinite, the colour blue can be associated with constancy. The quality of optimism is suggested by a clear sky.

Blue has long been associated with meditation and relaxation. Psychological research has found that blue slows down the metabolism and relaxes muscles.

Blue is generally a cool colour and some of its hues have associations of ice and steel. Picasso's "blue period" is symbolic of the rather melancholy aspects of blue. Such expressions as "feeling blue", "singing the blues", and "rhythm and blues" relate to depression and unhappiness.

"Shouting until blue in the face", "blue blood", and "blue with cold" all have their basis in quite literal situations: they refer, respectively, to lack of oxygen due to intense shouting; the fine, clear skin of pure breeding which allows blue veins to show; and very cold skin which becomes bluish as the veins contract in the cold.

Contradictory associations of blue are those of purity and pornography. The purest white is blue-white and yet the word "blue" is often applied to pornographic literature and films.

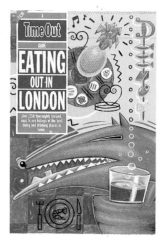

▲ Neither purple nor blue is naturally associated with food, but *Time Out* is an alternative magazine, and therefore the use of these contemporary colours for its restaurant guide is appropriate. These two colours, in conjunction with white separate the title banner and spine from the illustration, emphasizing the magazine's function.

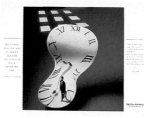

▲ The surrealist imagery of the clock face acknowledges Salvador Dali while graphically illustrating the copy. The blue tint alludes to a structured business lifestyle, the pale tints conveying the illusion of a prison cell window.

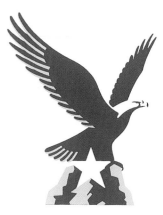

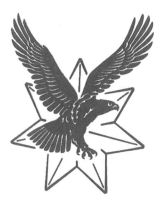

▲ The image above is the updated logo for Eagle Star Insurance Company. The early version below lacks authority and weight, compared to the powerful eagle standing on the rock. The subtle optical illusion of the white star has greater impact, through its use of space, than the drawn star below. The use of light and dark tones of blue in solid form for both the rock and eagle above, gives the new image authority and strength.

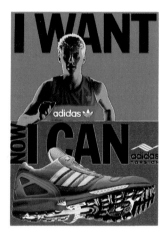

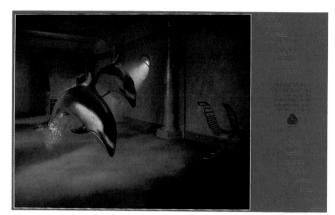

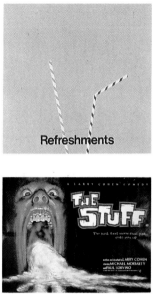

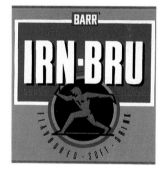

▲ The message of this poster, that of winning, is conveyed on three levels. First there is the optical effect of green behind red, projecting the runner; the red then stops the runner but in turn projects the shoe. Secondly, the two complementary colours give movement to the blue and yellow shoe. Finally, the typography works on different levels: the black on green, "I WANT", is subtle, but the black on red, "I CAN", is assertive.

▲ ▲ A summer sky, relaxing in the open with a refreshing drink – all this is implied with just a blue background and two straws. Red and yellow stripes suggest that there is a choice of interesting drinks. The bend in one of the straws conveys the idea that the place is informal and fun, while the broad expanse and the contrasting brighter colours suggest clean, cheerful surroundings.

▲ The first shock is that of seeing pink puke, the second, more horrific, impact comes from the grotesque green face spewing the vomit, but the most frightening and nightmarish sight is a turquoise-tinted, totally lifelike tongue. The combination is heart-stopping.

▲ We see a room full of water, but at the same time, through the clever use of lighter shades of blue, we are also aware that the floor is covered with luxurious, soft carpeting. The moody lighting recreates an ocean bed, and yet it seems perfectly acceptable to see a chair on the floor, complete with shadow on the wall, while the dolphins swim. The paradoxes blend naturally within these shades of blue, while the use of ocean blue for the surround strengthens the image.

▲ The strong, silent blue is at the very core of the label, providing a solid base from which the white brand name can project. Combined with orange it produces an effect that is both positive and powerful, while being compatible with the colours and imagery of the emblem. The blue is associated not only with strength but also with coolness.

Marketing

Blue is an extremely popular colour. Different shades appeal to different groups of people; navy blue has a classic feel, perhaps derived from its traditional use in naval uniforms; whereas turquoise has a bright, contemporary aspect.

Blue represents the purest form of white and therefore suggests the cleanliness offered by such products as detergents. In this context it is often combined with red, which adds connotations of effectiveness and power. Blue also represents water, further instilling the notion of cleanliness and is therefore suitable for face cleansers. Its masculine associations make it useful for products specifically designed for men.

Blue has strong connections with travel, and when used in advertisements and packaging has obvious associations with sky, sea and far-off places. Blue and yellow are summer colours, a natural combination in which the blue recedes to make the yellow project. This makes it suitable for dairy products as well as travel.

Blue is felt to be an extremely safe colour, and tends to be used for all forms of transportation. For this reason it is also associated with finance, used alone or with white. Blue and white make a particularly effective combination in any context, for together they have strong visibility.

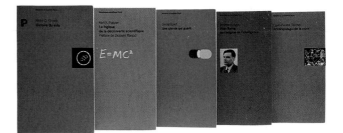

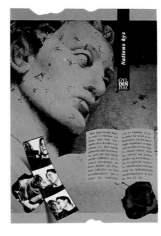

▲ Shades of blue provide visual continuity for a series of academic books. Although the books are restrained in style and have little added colour, they have a sophistication and individuality not normally connected with such serious literature.

If you rounded up every pair of blue jeans in the world, you'd find that the dye for one pair in four came from ICI.

▲ A sense of intrigue and decay is evoked by the blue tint. This allows the clues of the roses and photos to emerge, while leaving the written page shaded in mystery. The magenta of the rose harmonizes with the cyan tint, and yet is allowed to project to the foreground. The black banner with its white typography balances with the black and white photographs and roses. This contemporary cover is designed to appeal to an intelligent, young reader.

▲ Every element of this advertisement for blue jeans dye is brought together brilliantly through the use of colour. Typography, text, logo, clothing and locations are all related by the shade of blue. In the marketing of its dye, ICI is giving itself a human image which the public can relate to and understand.

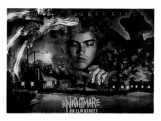

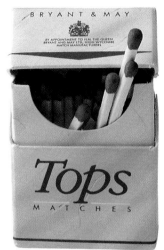

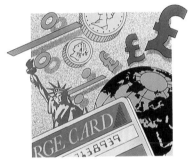

▲ Dark, light, and medium-tone shades of blue incorporated against an airbrushed background of the same tones contrasts with the golden yellow. The international world of finance is evident in the choice of both colour and graphics. This approach is designed to appeal to all ages.

▲ A total corporate identity for the bank has been created with royal blue and white. Immediately one associates it with money and banking, and yet because of the clarity of the blue and the purity of the white the bank is approachable. It is a youthful but responsible identity appealing to the young career person. The pastel colours reinforce the clean, youthful graphics, while the soft red of the keyboard suggests warmth and approachability.

▲ ▲ Tones of ink blue enshroud the figure in eerie shadows, conveying a sense of horror. Halloween orange typography echoes the lit windows, which indicate that no one can sleep on Elm Street. The emotive use of colour leaves one in little doubt as to what lies in store.

▲ A blue tone is used to create a luxurious scene designed to appeal to high-living, adventurous young people. The marketing of these watches has such a subtle approach that it is difficult to spot the product among the props. The red adds warmth to what could have been a cold image.

▲ Colour is the main marketing concept in this design. The muted pale blue pack with navy typography contains matches with blue heads, designed to be a fashion accessory. The blues create an image of cool cleanliness – a far cry from heat, fire, and ash.

▲ The logo effectively conveys and condenses information about the company. The strength of the grey imparts reliability while the contemporary use of this shade of blue states that it is a modern organization and implies connections with finance.

Culture and period

Blue has strong cultural links extending back in time to early religions, royalty and intellectual life.

Because blue is the colour of the sky and heavens, symbolic of the gods, the shrines in Hindu homes are painted blue. In early Christian paintings the Virgin Mary's cloak is always ultramarine blue. There are two theories behind this: blue is a "holy" colour, representing heaven; and ultramarine was a highly expensive pigment, costing as much as gold, and therefore appropriate for someone of her standing. It wasn't until the 19th century that synthetic paints were introduced and a cheaper blue became readily available. Colours such as lapis lazuli could now be used at the artist's whim, not only when specially commissioned and paid for by a patron. Despite its association with the Virgin Mary, blue is traditionally a masculine colour, whereas pink is for girls!

In 18th-century England, there was a group of people who gathered to discuss literary subjects, rather than playing cards as was more fashionable. They were dubbed the "Blue Stocking Society", after the eccentric blue worsted stockings worn by one member, Benjamin Stillingfleet. However, most members were women; and it was these intellectual women (and subsequently others of similar leanings) who bore the brunt of the mockery and the nickname "blue stocking".

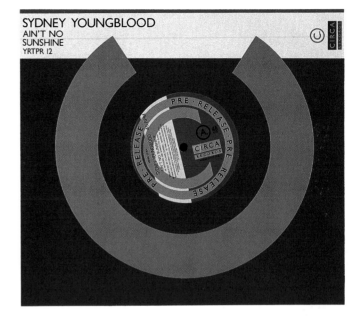

▲ A record cover is strongly reminiscent of the 1930s. It celebrates the superb design and colouring typical of Art Deco, and through its simplicity is timeless. The navy blue gives warmth to the gold and makes the white background to the caption most appropriate.

▲ The use of cyan and black, so popular in the 1950s, is combined here with appropriate typography and imagery to give the advertisement a 1950s look as well as providing an eye-catching contrast.

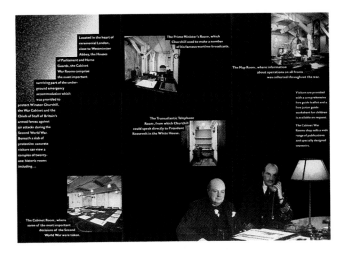

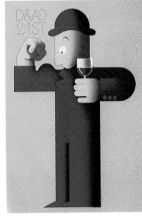

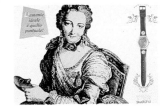

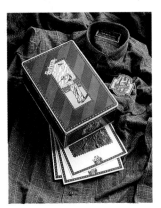

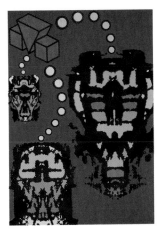

▲ The colour photographs mounted on an austere black background form an anachronism, while conveying the atmosphere of an underground bunker. The small patch of blue emphasizes the blackness, while toning with the duotone image of Winston Churchill in his war office. The blue tint subtly conveys the sense of period, contrasting with the contemporary colour pictures of the bunker as it is today.

▲ This is a modern interpretation of the original Dubonnet man. The figure is a typical Frenchman of the early 1950s, and although he is a businessman in a blue suit, this particular shade of cobalt implies that he has character and is full of life. A golden yellow background has the optical effect of projecting the blue-suited man and complements the glass of red Dubonnet.

▲ ▲ A hand-tinted portrait of Madame de Pompadour is related to the Swatch of the 1980s through the application of aqua. The red appears as an anachronism, making the Swatch contemporary.

▲ The imagery on the packaging reveals that the period setting is the 1920s. The colour palette within the illustration is also evocative of the period, and yet the purple and green when combined in stripes becomes modern.

▲ This is an example of late-1980s youth culture design. The palette of contemporary colours works not only as a semi-abstract painting, but also as propaganda for Red Wedge, a political association formed by British pop stars.

21

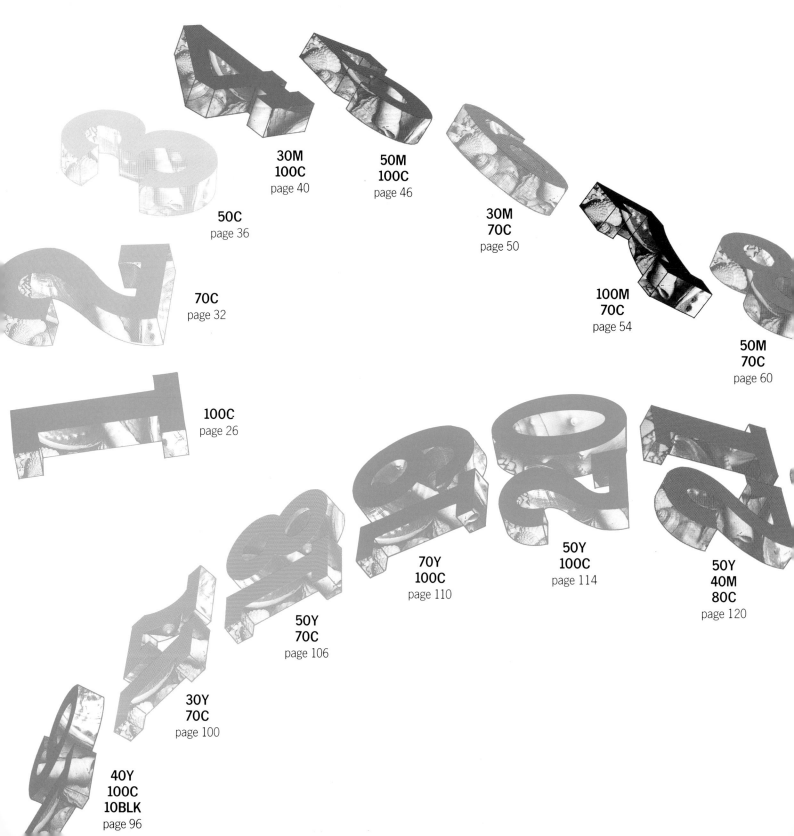

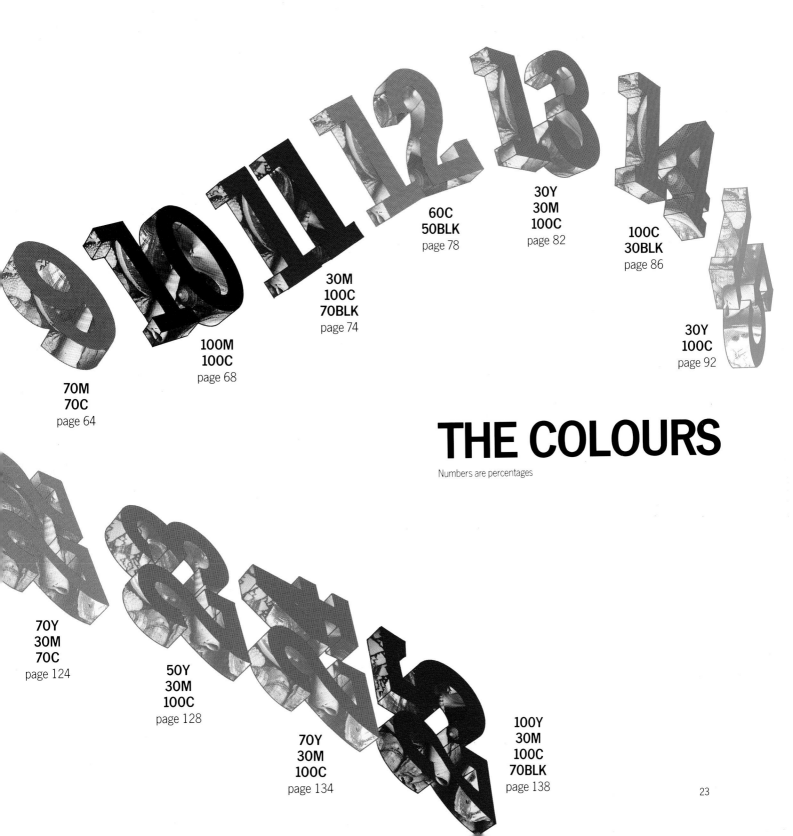

70M
70C
page 64

100M
100C
page 68

30M
100C
70BLK
page 74

60C
50BLK
page 78

30Y
30M
100C
page 82

100C
30BLK
page 86

30Y
100C
page 92

THE COLOURS

Numbers are percentages

70Y
30M
70C
page 124

50Y
30M
100C
page 128

70Y
30M
100C
page 134

100Y
30M
100C
70BLK
page 138

23

COLOURS ON TINTS

The 25 main colours are printed on background tints to simulate the effect of printing colour on printed stock. This chart can be used in a number of ways: as a guide to see how pale your chosen colour can go before it merges with the printed stock; to determine the aesthetic advantages of using a particular colour on a specific stock and to experiment with subtle patterns.

The corner flashes (triangles) show the main colour in its pure state, while the lettering shows the colour printed on the tint.

Green

Blue

Pink

Grey

Cream

| 100C | 70C | 50C | 30M 100C | 50M 100C | 30M 70C | 100M 70C | 50M 70C | 70M 70C | 100M 100C | 30M 100C 70BLK |

Numbers are percentages

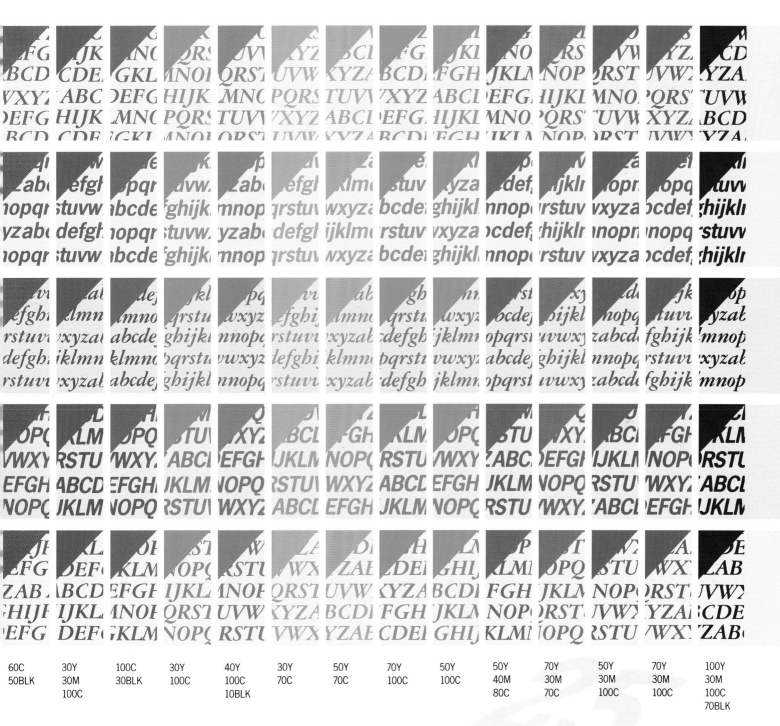

60C	30Y	100C	30Y	40Y	30Y	50Y	70Y	50Y	50Y	70Y	50Y	70Y	100Y
50BLK	30M	30BLK	100C	100C	70C	70C	100C	100C	40M	30M	30M	30M	30M
	100C			10BLK					80C	70C	100C	100C	100C
													70BLK

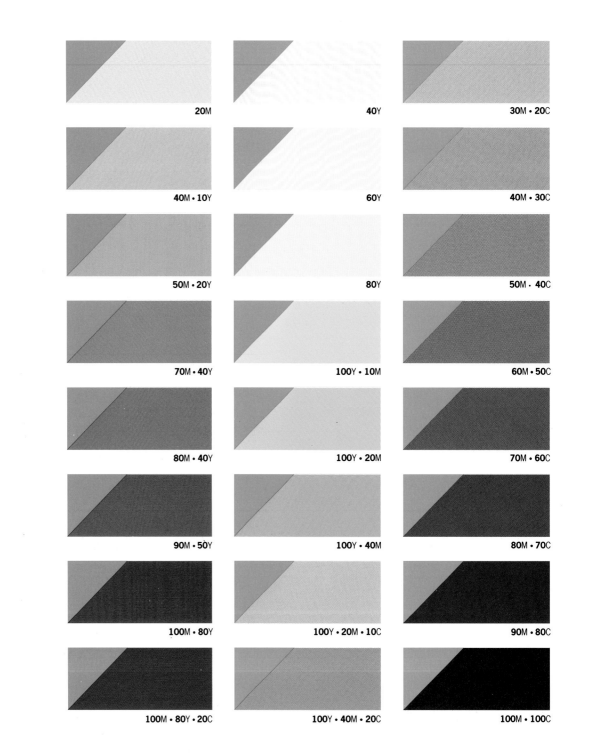

20M

40Y

30M · 20C

40M · 10Y

60Y

40M · 30C

50M · 20Y

80Y

50M · 40C

70M · 40Y

100Y · 10M

60M · 50C

80M · 40Y

100Y · 20M

70M · 60C

90M · 50Y

100Y · 40M

80M · 70C

100M · 80Y

100Y · 20M · 10C

90M · 80C

100M · 80Y · 20C

100Y · 40M · 20C

100M · 100C

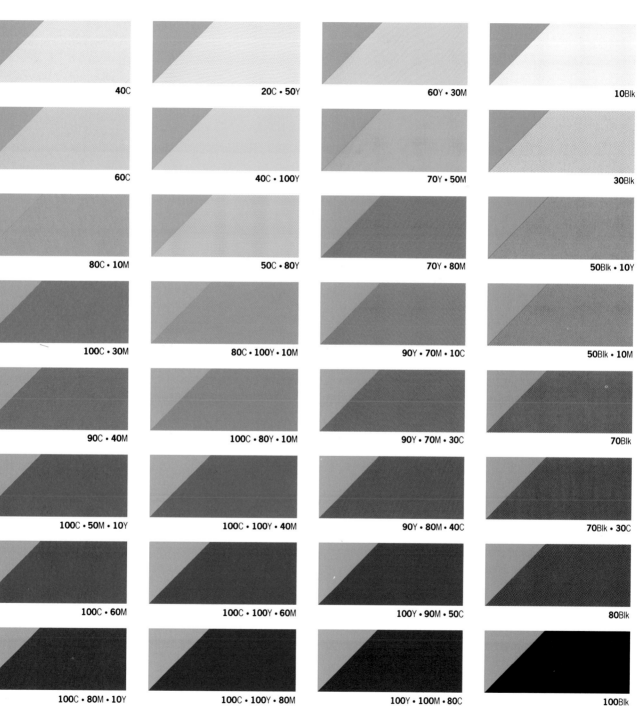

40C

20C • 50Y

60Y • 30M

10Blk

60C

40C • 100Y

70Y • 50M

30Blk

80C • 10M

50C • 80Y

70Y • 80M

50Blk • 10Y

100C • 30M

80C • 100Y • 10M

90Y • 70M • 10C

50Blk • 10M

90C • 40M

100C • 80Y • 10M

90Y • 70M • 30C

70Blk

100C • 50M • 10Y

100C • 100Y • 40M

90Y • 80M • 40C

70Blk • 30C

100C • 60M

100C • 100Y • 60M

100Y • 90M • 50C

80Blk

100C • 80M • 10Y

100C • 100Y • 80M

100Y • 100M • 80C

100Blk

27

NOTE: For technical information see page 6

100
90
80
70
60
50
40
30
20
10
0

Ossidet sterio binignuis
tultia, dolorat isogult it
gignuntisin stinuand. Flourida
prat gereafiunt quaecumque
trutent artsquati, quiateire
lurorist de corspore orum
semi uitantque tueri; sol etiam
caecat contra osidetsal utiquite

Ossidet sterio binignuis
tultia, dolorat isogult it
gignuntisin stinuand. Flourida
prat gereafiunt quaecumque
trutent artsquati, quiateire
lurorist de corspore orum
semi uitantque tueri; sol etiam
caecat contra osidetsal utiquite

Ossidet sterio binignuis
tultia, dolorat isogult it
gignuntisin stinuand. Flourida
prat gereafiunt quaecumque
trutent artsquati, quiateire
lurorist de corspore orum
semi uitantque tueri; sol etiam
caecat contra osidetsal utiquite

Ossidet sterio binignuis
tultia, dolorat isogult it
gignuntisin stinuand. Flourida
prat gereafiunt quaecumque
trutent artsquati, quiateire
lurorist de corspore orum
semi uitantque tueri; sol etiam
caecat contra osidetsal utiquite

100Blk H/T • H/T's: **100**C 100Blk H/T • H/T's: **50**C

50Blk H/T • H/T's: **100**C 50Blk H/T • H/T's: **50**C

100Blk H/T • F/T's: **100**C 100Blk H/T • F/T's: **50**C

H/T's: **100**C H/T's: **50**C

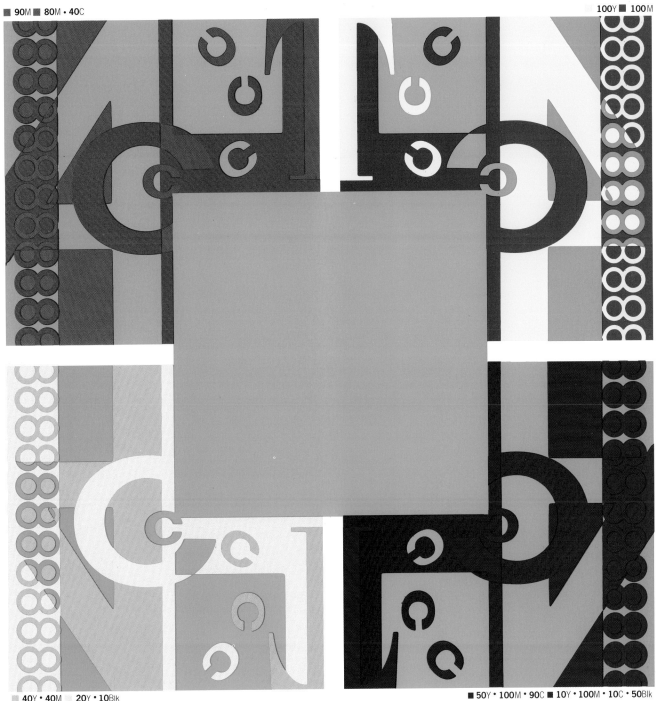

Cyan is one of the three process primary colours and is the starting point for all blues. Its brightness makes it highly visible, particularly with white or yellow.

◄ Process primaries give the page immediate impact. Cyan provides a solid background for the small but efficient areas of yellow and is given authority by the limited application of black. The colours form differing layers of dimension; for example, the black of the lettering advances, yet the white recedes. The cyan is there as a solid base to hold the attention and allow the other colours to perform.

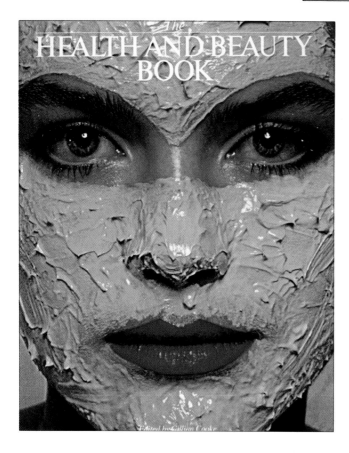

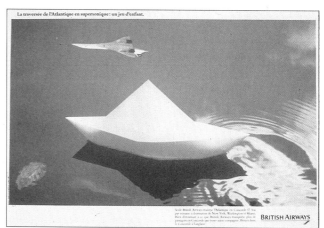

◄ The painterly, textural application of the cyan mask brings depth and life to the cover. The white typography on the cyan has instant impact, while presenting a pure almost clinical image; by contrast, the sensual red lips surrounded by the blue are almost decadent. The cyan of the face and mask enhances the tantalizing glimpses of healthy skin, reveals exotic eyes and highlights their sparkle.

▲ The use of cyan as a background, providing sky for Concorde to fly through and water for the origami boat to sail on, unites traditional and high tech design. The innocent clarity of the cyan set against the white implies that flying across the Atlantic is child's play.

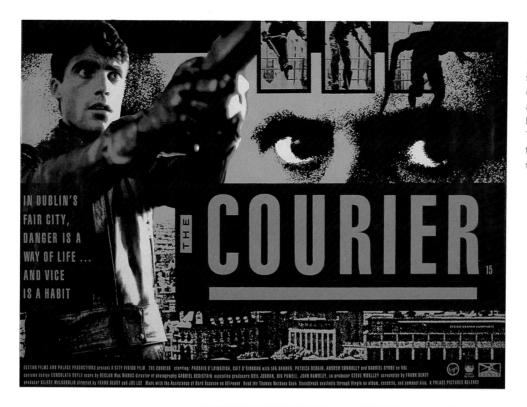

◄ Bold cyan typography brings strength and simplicity to an otherwise complex colour palette. The images and colours telling different stories become a backcloth for the blue print. The white of the eyes, complementing the cyan, beguiles the viewer into reading the dominant title credit.

► Blue-white is the purest white known. By using a powerful, white animal, a polar bear, and tinting it with the blue of the product label, the designer has created an eye-catching and memorable advertisement. The subtlety of the cyan-tinted bear on a black background is given greater impact by the white strip bearing the caption "White should always be blue".

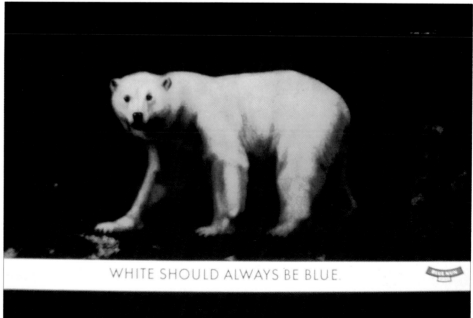

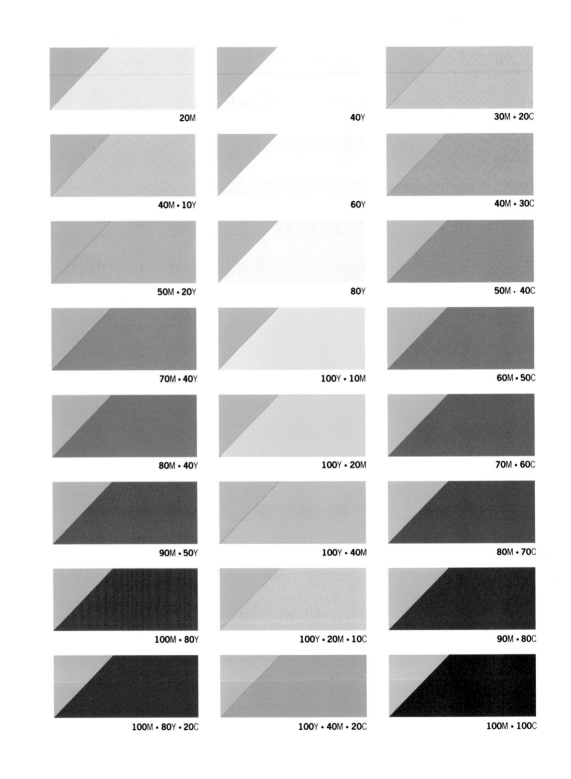

20M

40Y

30M · 20C

40M · 10Y

60Y

40M · 30C

50M · 20Y

80Y

50M · 40C

70M · 40Y

100Y · 10M

60M · 50C

80M · 40Y

100Y · 20M

70M · 60C

90M · 50Y

100Y · 40M

80M · 70C

100M · 80Y

100Y · 20M · 10C

90M · 80C

100M · 80Y · 20C

100Y · 40M · 20C

100M · 100C

40C

20C • 50Y

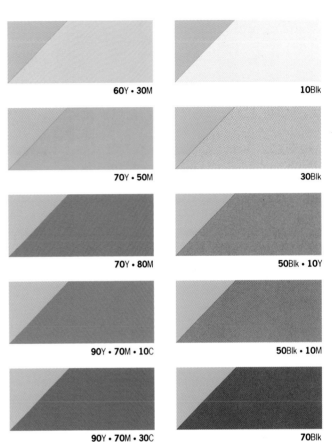
60Y • 30M

10Blk

60C

40C • 100Y

70Y • 50M

30Blk

80C • 10M

50C • 80Y

70Y • 80M

50Blk • 10Y

100C • 30M

80C • 100Y • 10M

90Y • 70M • 10C

50Blk • 10M

90C • 40M

100C • 80Y • 10M

90Y • 70M • 30C

70Blk

100C • 50M • 10Y

100C • 100Y • 40M

90Y • 80M • 40C

70Blk • 30C

100C • 60M

100C • 100Y • 60M

100Y • 90M • 50C

80Blk

100C • 80M • 10Y

100C • 100Y • 80M

100Y • 100M • 80C

100Blk

NOTE: For technical information see page 6

Ossidet sterio binignuis
tultia, dolorat isogult it
gignuntisin stinuand. Flourida
prat gereafiunt quaecumque
trutent artsquati, quiateire
lurorist de corspore orum
semi uitantque tueri; sol etiam
caecat contra osidetsal utiquite

100Blk H/T • H/T's: **70**C 100Blk H/T • H/T's: **35**C

Ossidet sterio binignuis
tultia, dolorat isogult it
gignuntisin stinuand. Flourida
prat gereafiunt quaecumque
trutent artsquati, quiateire
lurorist de corspore orum
semi uitantque tueri; sol etiam
caecat contra osidetsal utiquite

50Blk H/T • H/T's:**70**C 50Blk H/T • H/T's: **35**C

Ossidet sterio binignuis
tultia, dolorat isogult it
gignuntisin stinuand. Flourida
prat gereafiunt quaecumque
trutent artsquati, quiateire
lurorist de corspore orum
semi uitantque tueri; sol etiam
caecat contra osidetsal utiquite

100Blk H/T • F/T's: **70**C 100Blk H/T • F/T's: **35**C

Ossidet sterio binignuis
tultia, dolorat isogult it
gignuntisin stinuand. Flourida
prat gereafiunt quaecumque
trutent artsquati, quiateire
lurorist de corspore orum
semi uitantque tueri; sol etiam
caecat contra osidetsal utiquite

H/T's: **70**C H/T's: **35**C

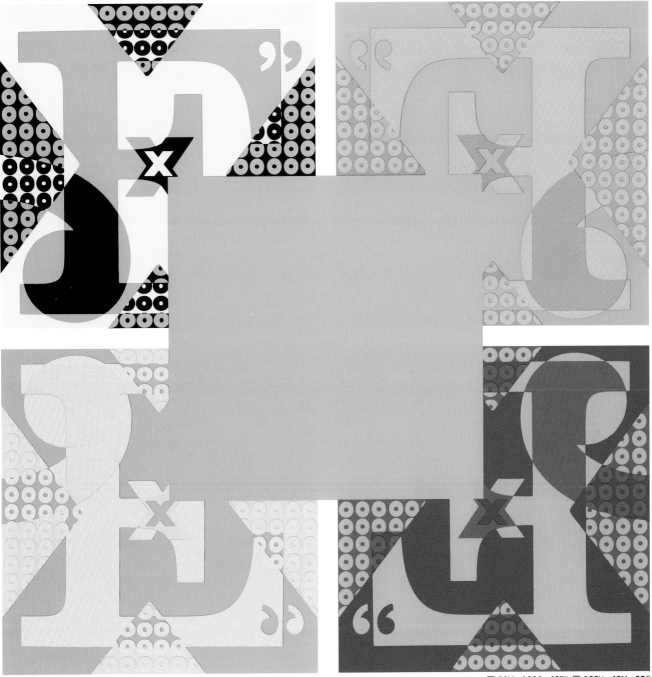

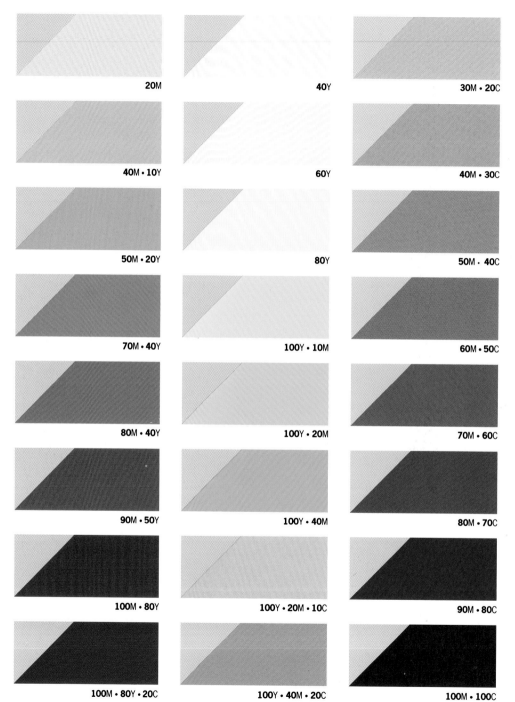

20M

40Y

30M · 20C

40M · 10Y

60Y

40M · 30C

50M · 20Y

80Y

50M · 40C

70M · 40Y

100Y · 10M

60M · 50C

80M · 40Y

100Y · 20M

70M · 60C

90M · 50Y

100Y · 40M

80M · 70C

100M · 80Y

100Y · 20M · 10C

90M · 80C

100M · 80Y · 20C

100Y · 40M · 20C

100M · 100C

 40C

 20C • 50Y

 60Y • 30M

 10Blk

 60C

 40C • 100Y

 70Y • 50M

 30Blk

 80C • 10M

 50C • 80Y

 70Y • 80M

 50Blk • 10Y

100C • 30M

 80C • 100Y • 10M

 90Y • 70M • 10C

50Blk • 10M

 90C • 40M

100C • 80Y • 10M

90Y • 70M • 30C

70Blk

 100C • 50M • 10Y

100C • 100Y • 40M

90Y • 80M • 40C

 70Blk • 30C

100C • 60M

100C • 100Y • 60M

 100Y • 90M • 50C

80Blk

 100C • 80M • 10Y

100C • 100Y • 80M

 100Y • 100M • 80Blk

 100Blk

50C

Ossidet sterio binignuis
tultia, dolorat isogult it
gignuntisin stinuand. Flourida
prat gereafiunt quaecumque
trutent artsquati, quiateire
lurorist de corspore orum
semi uitantque tueri; sol etiam
caecat contra osidetsal utiquite

Ossidet sterio binignuis
tultia, dolorat isogult it
gignuntisin stinuand. Flourida
prat gereafiunt quaecumque
trutent artsquati, quiateire
lurorist de corspore orum
semi uitantque tueri; sol etiam
caecat contra osidetsal utiquite

Ossidet sterio binignuis
tultia, dolorat isogult it
gignuntisin stinuand. Flourida
prat gereafiunt quaecumque
trutent artsquati, quiateire
lurorist de corspore orum
semi uitantque tueri; sol etiam
caecat contra osidetsal utiquite

Ossidet sterio binignuis
tultia, dolorat isogult it
gignuntisin stinuand. Flourida
prat gereafiunt quaecumque
trutent artsquati, quiateire
lurorist de corspore orum
semi uitantque tueri; sol etiam
caecat contra osidetsal utiquite

100Blk H/T • H/T's: **50**C 100Blk H/T • H/T's: **25**C

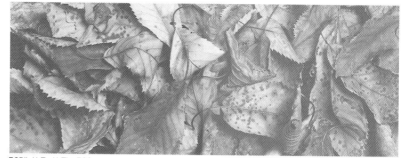

50Blk H/T • H/T's: **50**C 50Blk H/T • H/T's: **25**C

100Blk H/T • F/T's: **50**C 100Blk H/T • F/T's: **25**C

H/T's: **50**C H/T's: **25**C

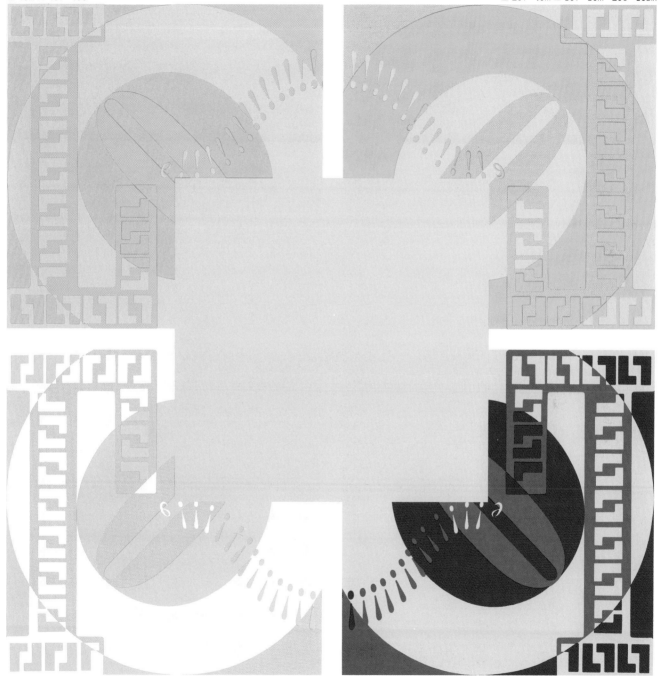

30M · 100C

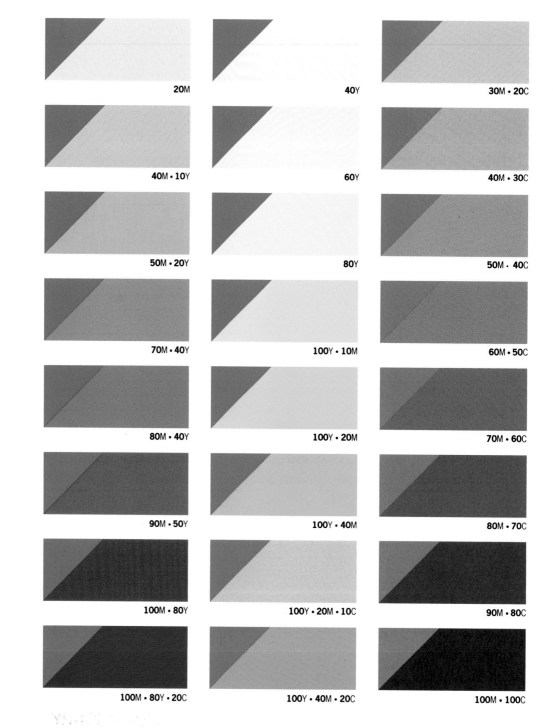

20M

40Y

30M · 20C

40M · 10Y

60Y

40M · 30C

50M · 20Y

80Y

50M · 40C

70M · 40Y

100Y · 10M

60M · 50C

80M · 40Y

100Y · 20M

70M · 60C

90M · 50Y

100Y · 40M

80M · 70C

100M · 80Y

100Y · 20M · 10C

90M · 80C

100M · 80Y · 20C

100Y · 40M · 20C

100M · 100C

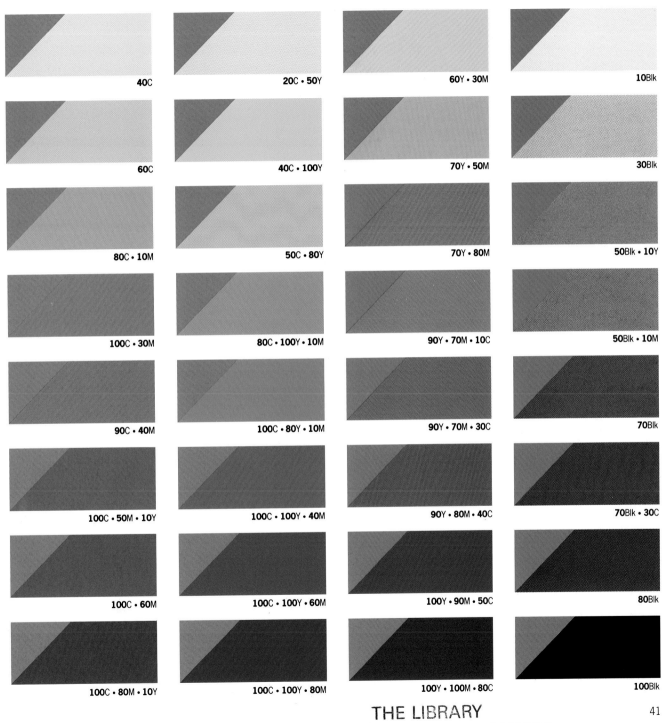

40C

20C • 50Y

60Y • 30M

10Blk

60C

40C • 100Y

70Y • 50M

30Blk

80C • 10M

50C • 80Y

70Y • 80M

50Blk • 10Y

100C • 30M

80C • 100Y • 10M

90Y • 70M • 10C

50Blk • 10M

90C • 40M

100C • 80Y • 10M

90Y • 70M • 30C

70Blk

100C • 50M • 10Y

100C • 100Y • 40M

90Y • 80M • 40C

70Blk • 30C

100C • 60M

100C • 100Y • 60M

100Y • 90M • 50C

80Blk

100C • 80M • 10Y

100C • 100Y • 80M

100Y • 100M • 80C

100Blk

30M · 100C

NOTE: For technical information see page 6

Ossidet sterio binignuis
tultia, dolorat isogult it
gignuntisin stinuand. Flourida
prat gereafiunt quaecumque
trutent artsquati, quiateire
lurorist de corspore orum
semi uitantque tueri; sol etiam
caecat contra osidetsal utiquite

100Blk H/T • H/T's: **30M** • **100C**

100Blk H/T • H/T's: **15M** • **50C**

Ossidet sterio binignuis
tultia, dolorat isogult it
gignuntisin stinuand. Flourida
prat gereafiunt quaecumque
trutent artsquati, quiateire
lurorist de corspore orum
semi uitantque tueri; sol etiam
caecat contra osidetsal utiquite

50Blk H/T • H/T's: **30M** • **100C**

50Blk H/T • H/T's: **15M** • **50C**

Ossidet sterio binignuis
tultia, dolorat isogult it
gignuntisin stinuand. Flourida
prat gereafiunt quaecumque
trutent artsquati, quiateire
lurorist de corspore orum
semi uitantque tueri; sol etiam
caecat contra osidetsal utiquite

100Blk H/T • F/T's: **30M** • **100C**

100Blk H/T • F/T's: **15M** • **50C**

Ossidet sterio binignuis
tultia, dolorat isogult it
gignuntisin stinuand. Flourida
prat gereafiunt quaecumque
trutent artsquati, quiateire
lurorist de corspore orum
semi uitantque tueri; sol etiam
caecat contra osidetsal utiquite

H/T's: **30M** • **100C**

H/T's: **15M** • **50C**

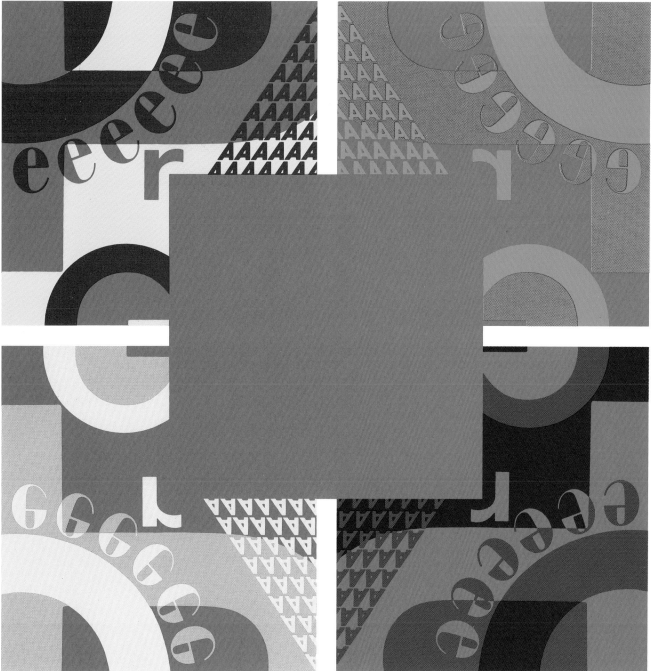

Natural elements – water, sky and ice – are represented by these colours. Taken a step further, the colours are associated with cleanliness and movement. Cyan has evolved into a classic blue.

▶ The black cover, with its simple, yet sophisticated white typography and graphics, has instant impact. The subtlety of the cobalt illustration not only depicts the title of the book, but also, through the psychological association of blue with water, and the literal application of blue on black, drowns the imagery.

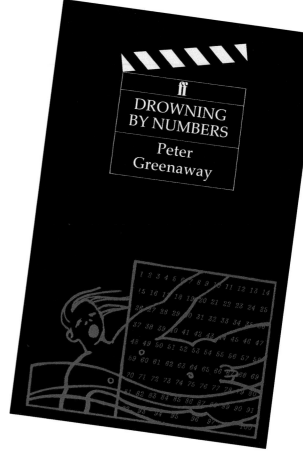

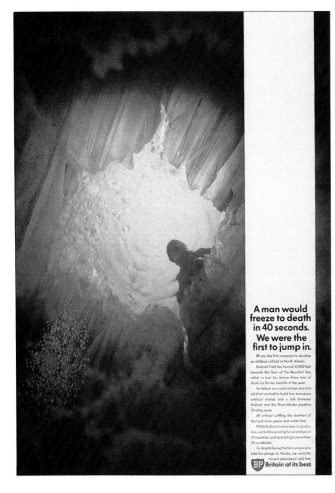

A man would freeze to death in 40 seconds. We were the first to jump in.

BP was the first company to develop an offshore oilfield in North Alaska. Endicott Field lies buried 10,000 feet beneath the floor of the Beaufort Sea, which in turn lies below three feet of Arctic ice for ten months of the year.

So before we could extract one barrel of oil we had to build two enormous artificial islands and a link between Endicott and the Trans-Alaska pipeline, 24 miles away.

All without ruffling the feathers of the local snow geese and water fowl.

While Endicott is now near to production, we're still exploring for oil and gas in 29 countries and operating in more than 70 worldwide.

So despite being the first company to take the plunge in Alaska, we certainly haven't developed cold feet.

BP Britain at its best.

◀ Tones of ice blue evoke a frozen, hostile environment. The unforgiving texture of ice and the coldness of the arctic water are created through the deepening and lightening of the same blue. The hue is then intensified and strengthened to form the shape of a person at the cavern mouth.

▶ Using the fresh cornflower blue of the logo for the shoutlines focuses attention on them, as well as complementing the magenta typography. Together these shades add to the playful nature of the magazine cover. Tradition has been adhered to in the use of blue for a boy!

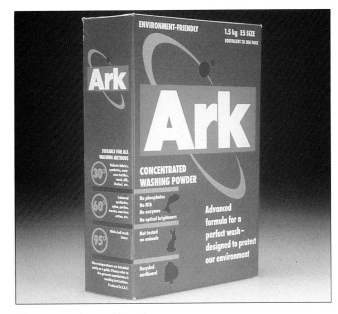

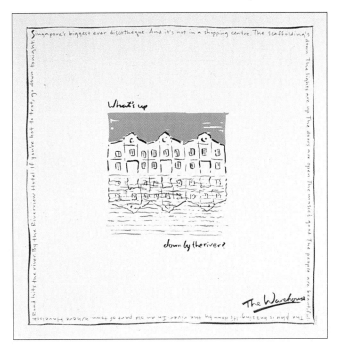

▼ The solid blue of the sky reinforces the text, "What's up" while the broken shades of the water take the observer "down". The innocent nature of the blue works effectively with the sketched graphics and the handwritten typography.

▲ The association between blue, water, and cleanliness is reinforced by the cornflower blue, while the clean-cut images in aqua, white, orange, and red form a striking colour combination, reinforcing the concept of power behind this washing powder. Although environment-friendly, the product is packaged in strong coloration rather than the muted shades used by similar "green" products.

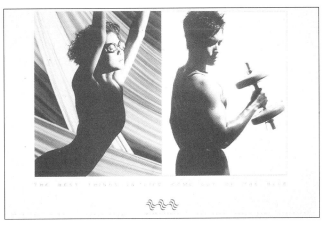

◄ "The best things come out of the blue". Tones of ink blue moodily darkened into shadows and lightened into highlights project these beautiful figures. The tones give the female form a floating, ethereal effect, while the lack of background colour in the second image highlights the more solid masculine form.

50M · 100C

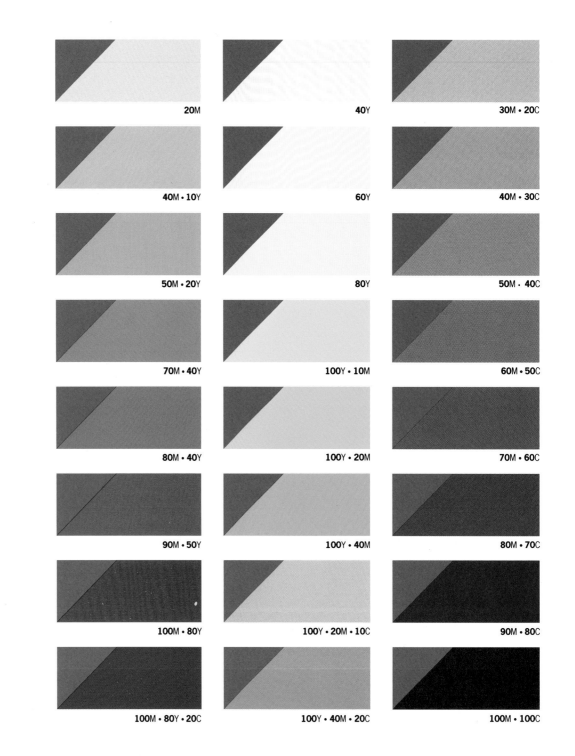

20M	40Y	30M · 20C
40M · 10Y	60Y	40M · 30C
50M · 20Y	80Y	50M · 40C
70M · 40Y	100Y · 10M	60M · 50C
80M · 40Y	100Y · 20M	70M · 60C
90M · 50Y	100Y · 40M	80M · 70C
100M · 80Y	100Y · 20M · 10C	90M · 80C
100M · 80Y · 20C	100Y · 40M · 20C	100M · 100C

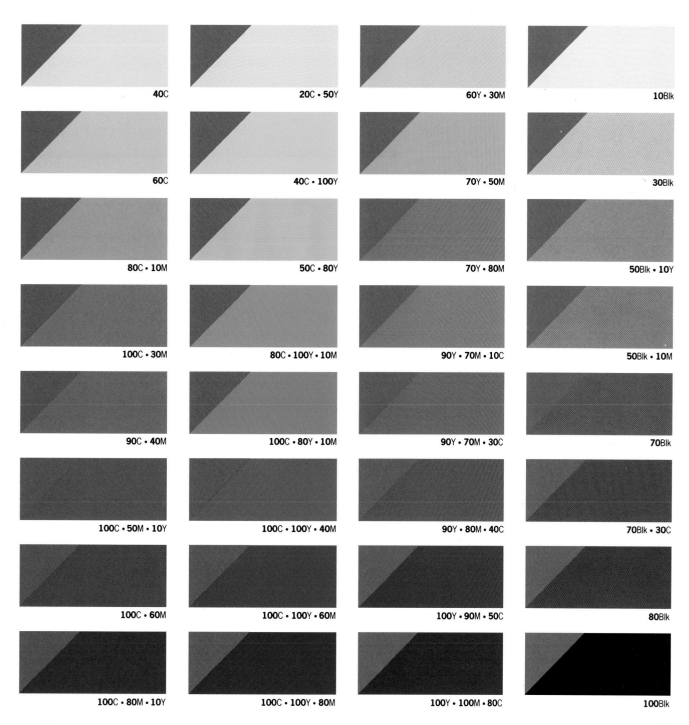

40C

20C • 50Y

60Y • 30M

10Blk

60C

40C • 100Y

70Y • 50M

30Blk

80C • 10M

50C • 80Y

70Y • 80M

50Blk • 10Y

100C • 30M

80C • 100Y • 10M

90Y • 70M • 10C

50Blk • 10M

90C • 40M

100C • 80Y • 10M

90Y • 70M • 30C

70Blk

100C • 50M • 10Y

100C • 100Y • 40M

90Y • 80M • 40C

70Blk • 30C

100C • 60M

100C • 100Y • 60M

100Y • 90M • 50C

80Blk

100C • 80M • 10Y

100C • 100Y • 80M

100Y • 100M • 80C

100Blk

50M · 100C

NOTE: For technical information see page 6

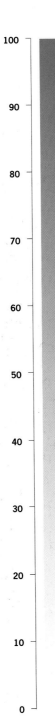

100 90 80 70 60 50 40 30 20 10 0

Ossidet sterio binignuis tultia, dolorat isogult it gignuntisin stinuand. Flourida prat gereafiunt quaecumque **trutent artsquati, quiateire lurorist de corspore orum** semi uitantque tueri; sol etiam caecat contra osidetsal utiquite

Ossidet sterio binignuis tultia, dolorat isogult it gignuntisin stinuand. Flourida prat gereafiunt quaecumque **trutent artsquati, quiateire lurorist de corspore orum** semi uitantque tueri; sol etiam caecat contra osidetsal utiquite

Ossidet sterio binignuis tultia, dolorat isogult it gignuntisin stinuand. Flourida prat gereafiunt quaecumque **trutent artsquati, quiateire lurorist de corspore orum** semi uitantque tueri; sol etiam caecat contra osidetsal utiquite

Ossidet sterio binignuis tultia, dolorat isogult it gignuntisin stinuand. Flourida prat gereafiunt quaecumque **trutent artsquati, quiateire lurorist de corspore orum** semi uitantque tueri; sol etiam caecat contra osidetsal utiquite

100Blk H/T • H/T's: **50M • 100**C 100Blk H/T • H/T's: **25M • 50**C

50Blk H/T • H/T's: **50M • 100**C 50Blk H/T • H/T's: **25M • 50**C

100Blk H/T • F/T's: **50M • 100**C 100Blk H/T • F/T's: **25M • 50**C

H/T's: **50M • 100**C H/T's: **25M • 50**C

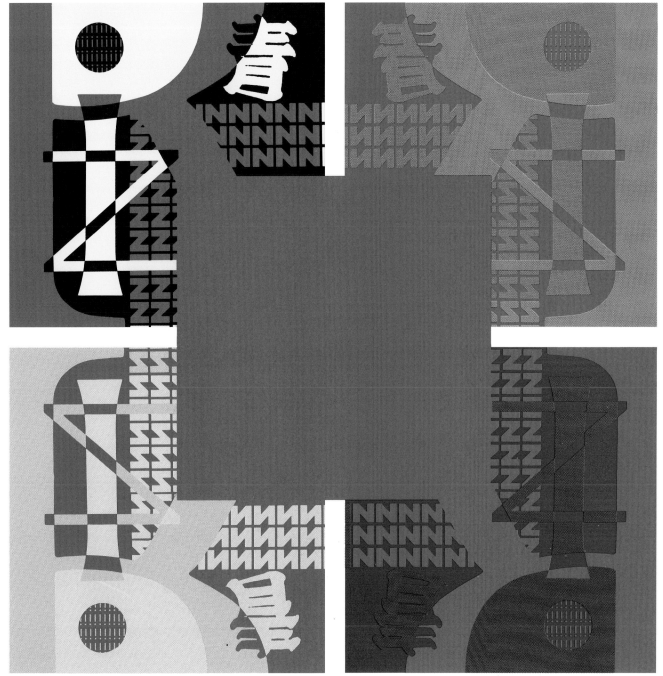

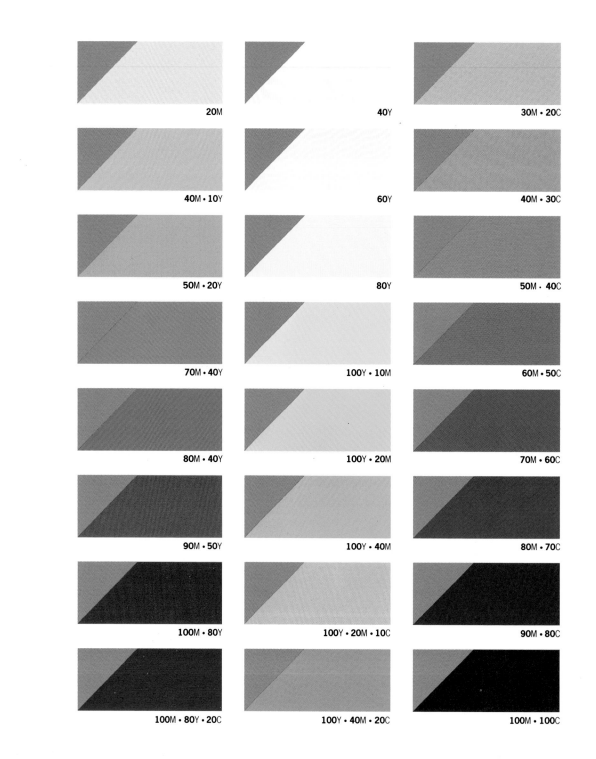

20M

40Y

30M · 20C

40M · 10Y

60Y

40M · 30C

50M · 20Y

80Y

50M · 40C

70M · 40Y

100Y · 10M

60M · 50C

80M · 40Y

100Y · 20M

70M · 60C

90M · 50Y

100Y · 40M

80M · 70C

100M · 80Y

100Y · 20M · 10C

90M · 80C

100M · 80Y · 20C

100Y · 40M · 20C

100M · 100C

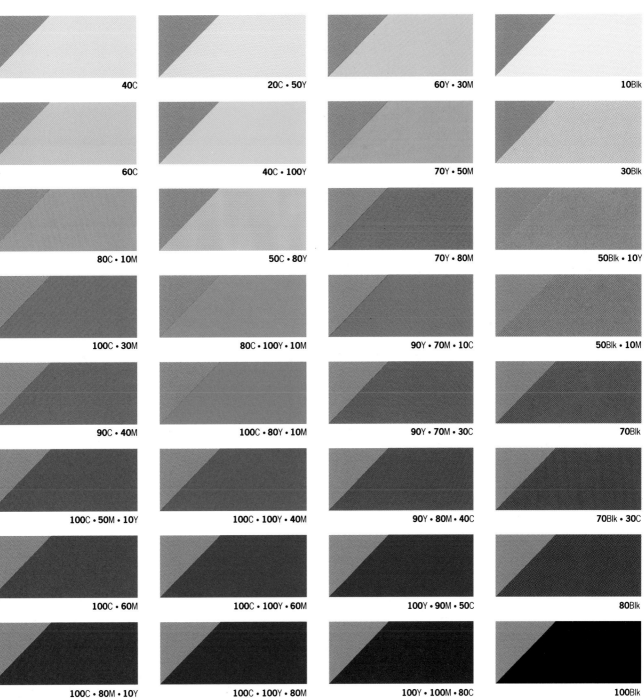

40C	20C • 50Y	60Y • 30M	10Blk
60C	40C • 100Y	70Y • 50M	30Blk
80C • 10M	50C • 80Y	70Y • 80M	50Blk • 10Y
100C • 30M	80C • 100Y • 10M	90Y • 70M • 10C	50Blk • 10M
90C • 40M	100C • 80Y • 10M	90Y • 70M • 30C	70Blk
100C • 50M • 10Y	100C • 100Y • 40M	90Y • 80M • 40C	70Blk • 30C
100C • 60M	100C • 100Y • 60M	100Y • 90M • 50C	80Blk
100C • 80M • 10Y	100C • 100Y • 80M	100Y • 100M • 80C	100Blk

NOTE: For technical information see page 6

100
90
80
70
60
50
40
30
20
10
0

Ossidet sterio binignuis tultia, dolorat isogult it gignuntisin stinuand. Flourida prat gereafiunt quaecumque trutent artsquati, quiateire lurorist de corspore orum semi uitantque tueri; sol etiam caecat contra osidetsal utiquite

Ossidet sterio binignuis tultia, dolorat isogult it gignuntisin stinuand. Flourida prat gereafiunt quaecumque trutent artsquati, quiateire lurorist de corspore orum semi uitantque tueri; sol etiam caecat contra osidetsal utiquite

Ossidet sterio binignuis tultia, dolorat isogult it gignuntisin stinuand. Flourida prat gereafiunt quaecumque trutent artsquati, quiateire lurorist de corspore orum semi uitantque tueri; sol etiam caecat contra osidetsal utiquite

Ossidet sterio binignuis tultia, dolorat isogult it gignuntisin stinuand. Flourida prat gereafiunt quaecumque trutent artsquati, quiateire lurorist de corspore orum semi uitantque tueri; sol etiam caecat contra osidetsal utiquite

100Blk H/T · H/T's: **30M · 70C** 100Blk H/T · H/T's: **15M · 35C**

50Blk H/T · H/T's: **30M · 70C** 50Blk H/T · H/T's: **15M · 35C**

100Blk H/T · F/T's: **30M · 70C** 100Blk H/T · F/T's: **15M · 35C**

H/T's: **30M · 70C** H/T's: **15M · 35C**

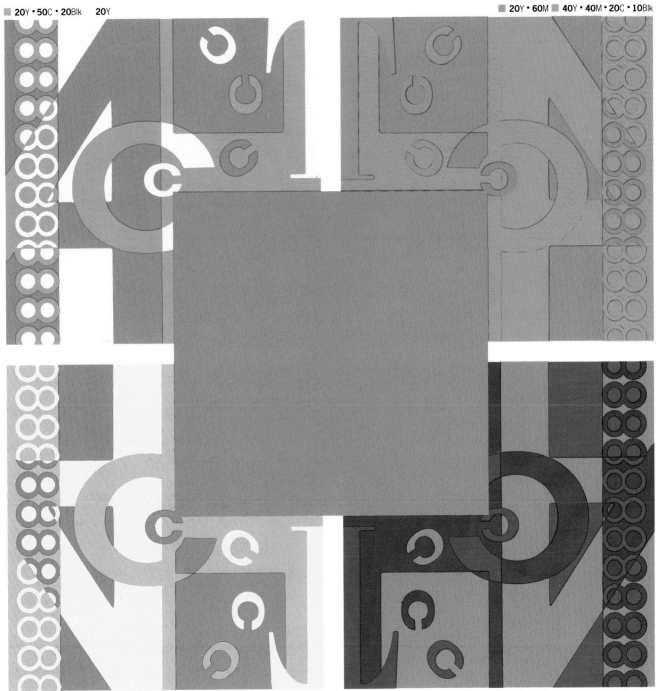

20Y • 50C • 20Blk 20Y

20Y • 60M 40Y • 40M • 20C • 10Blk

10M 30Blk

70M • 30C • 40Blk 80Y • 80M • 20C • 10Blk

20M

40Y

30M · 20C

40M · 10Y

60Y

40M · 30C

50M · 20Y

80Y

50M · 40C

70M · 40Y

100Y · 10M

60M · 50C

80M · 40Y

100Y · 20M

70M · 60C

90M · 50Y

100Y · 40M

80M · 70C

100M · 80Y

100Y · 20M · 10C

90M · 80C

100M · 80Y · 20C

100Y · 40M · 20C

100M · 100C

40C	20C · 50Y	60Y · 30M	10Blk
60C	40C · 100Y	70Y · 50M	30Blk
80C · 10M	50C · 80Y	70Y · 80M	50Blk · 10Y
100C · 30M	80C · 100Y · 10M	90Y · 70M · 10C	50Blk · 10M
90C · 40M	100C · 80Y · 10M	90Y · 70M · 30C	70Blk
100C · 50M · 10Y	100C · 100Y · 40M	90Y · 80M · 40C	70Blk · 30C
100C · 60M	100C · 100Y · 60M	100Y · 90M · 50C	80Blk
100C · 80M · 10Y	100C · 100Y · 80M	100Y · 100M · 80C	100Blk

100M · 70C

NOTE: For technical information see page 6

Ossidet sterio binignuis tultia, dolorat isogult it gignuntisin stinuand. Flourida prat gereafiunt quaecumque **trutent artsquati, quiateire lurorist de corspore orum** semi uitantque tueri; sol etiam caecat contra osidetsal utiquite

100Blk H/T • H/T's: **100M** • **70**C 100Blk H/T • H/T's: **50M** • **35**C

Ossidet sterio binignuis tultia, dolorat isogult it gignuntisin stinuand. Flourida prat gereafiunt quaecumque **trutent artsquati, quiateire lurorist de corspore orum** semi uitantque tueri; sol etiam caecat contra osidetsal utiquite

50Blk H/T • H/T's: **100M** • **70**C 50Blk H/T • H/T's: **50M** • **35**C

Ossidet sterio binignuis tultia, dolorat isogult it gignuntisin stinuand. Flourida prat gereafiunt quaecumque **trutent artsquati, quiateire lurorist de corspore orum** semi uitantque tueri; sol etiam caecat contra osidetsal utiquite

100Blk H/T • F/T's: **100M** • **70**C 100Blk H/T • F/T's: **50M** • **35**C

Ossidet sterio binignuis tultia, dolorat isogult it gignuntisin stinuand. Flourida prat gereafiunt quaecumque **trutent artsquati, quiateire lurorist de corspore orum** semi uitantque tueri; sol etiam caecat contra osidetsal utiquite

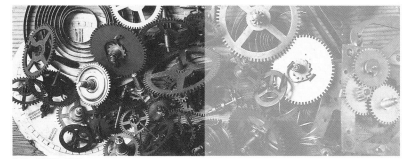

H/T's: **100M** • **70**C H/T's: **50M** • **35**C

*Schizophrenic blues!
These are the blues of
Billie Holiday and Ella
Fitzgerald, soft and
moody when merging
with deep mellow tones
such as aubergine
and midnight blue.
Yet, introduce red
or white in solid form,
and they become alive
and alert.*

◀ The way this deep, rich blue has been used in both the typography and the illustration gives two different impressions, and yet unites them at the same time. The blue of the text becomes strong and authoritative when contrasted with its stark white background, but combined with red and royal blue in the illustration, the blue softens and becomes animated.

▼ The steel blue forms a sophisticated background to the typography and is picked up in tints on the glass and the liquid. This shade of blue, when used in conjunction with white, underlines the purity of the rum; while the fragile glass is strengthened by the steely nature of the colour, giving credibility to the caption. "Knock the stuffing out of a Piña Colada".

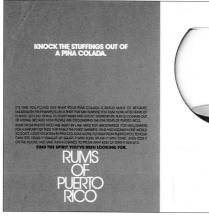

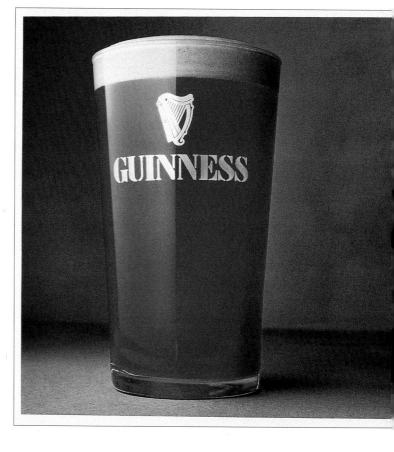

► Tones of blackened blue create a horrifying image of ruthless steel crushing down on a hapless victim, while her pink tutu softly echoes the pink of the nail varnish that will help to save her life. The blue-black shade is continued in the typography and adds a menacing tone to the text. Lucky indeed that her nails were long!

◄ This advertisement is both startling and memorable through the use of psychological shock tactics and automatic association. The British public knows that a glass of Guinness is black, yet here it is in bright blue. The designer has, with tremendous effect, used totally realistic photography while cleverly transposing the colours of the subject and background.

► The depth and interplay of colour on this brochure page celebrate both typography and colour. The deep, soft, blackened blue provides a base for the interlayering of mustard, grey and white, giving prime visibility to the white text.

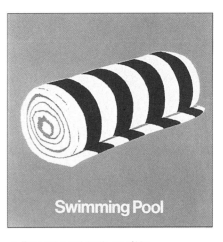

▲ This positive and simple use of blue and white tells an entire story. The pale blue implies that there is refreshing, clean water; the navy and white towel is tactile and inviting. The only option is to go swimming!

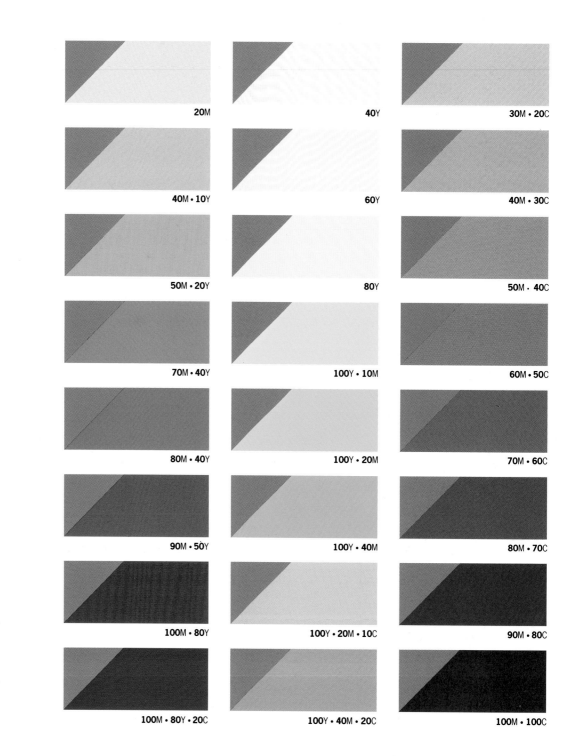

20M

40Y

30M · 20C

40M · 10Y

60Y

40M · 30C

50M · 20Y

80Y

50M · 40C

70M · 40Y

100Y · 10M

60M · 50C

80M · 40Y

100Y · 20M

70M · 60C

90M · 50Y

100Y · 40M

80M · 70C

100M · 80Y

100Y · 20M · 10C

90M · 80C

100M · 80Y · 20C

100Y · 40M · 20C

100M · 100C

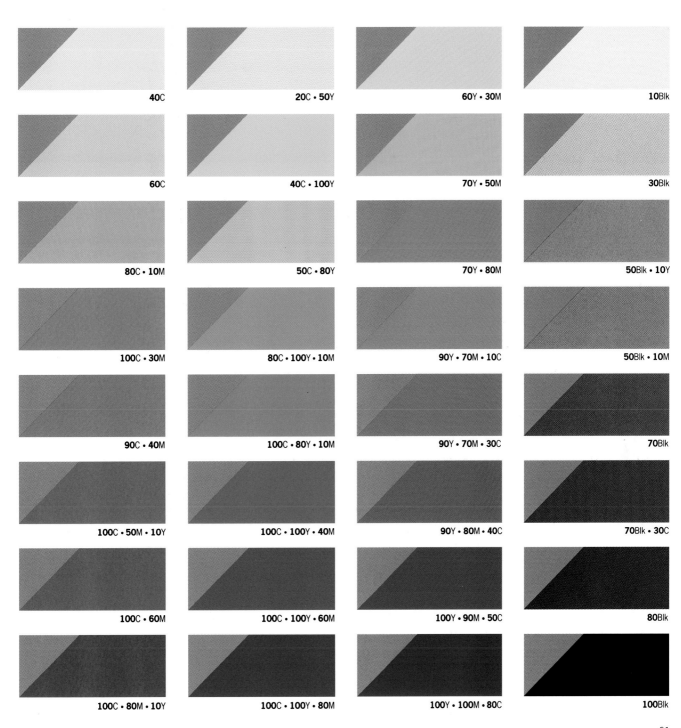

40C	20C • 50Y	60Y • 30M	10Blk
60C	40C • 100Y	70Y • 50M	30Blk
80C • 10M	50C • 80Y	70Y • 80M	50Blk • 10Y
100C • 30M	80C • 100Y • 10M	90Y • 70M • 10C	50Blk • 10M
90C • 40M	100C • 80Y • 10M	90Y • 70M • 30C	70Blk
100C • 50M • 10Y	100C • 100Y • 40M	90Y • 80M • 40C	70Blk • 30C
100C • 60M	100C • 100Y • 60M	100Y • 90M • 50C	80Blk
100C • 80M • 10Y	100C • 100Y • 80M	100Y • 100M • 80C	100Blk

50M · 70C

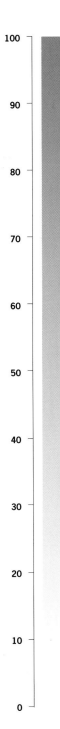

100
90
80
70
60
50
40
30
20
10
0

Ossidet sterio binignuis tultia, dolorat isogult it gignuntisin stinuand. Flourida prat gereafiunt quaecumque **trutent artsquati, quiateire lurorist de corspore orum** semi uitantque tueri; sol etiam caecat contra osidetsal utiquite

Ossidet sterio binignuis tultia, dolorat isogult it gignuntisin stinuand. Flourida prat gereafiunt quaecumque trutent artsquati, quiateire lurorist de corspore orum semi uitantque tueri; sol etiam caecat contra osidetsal utiquite

Ossidet sterio binignuis tultia, dolorat isogult it gignuntisin stinuand. Flourida prat gereafiunt quaecumque **trutent artsquati, quiateire lurorist de corspore orum** semi uitantque tueri; sol etiam caecat contra osidetsal utiquite

Ossidet sterio binignuis tultia, dolorat isogult it gignuntisin stinuand. Flourida prat gereafiunt quaecumque **trutent artsquati, quiateire lurorist de corspore orum** semi uitantque tueri; sol etiam caecat contra osidetsal utiquite

NOTE: For technical information see page 6

100Blk H/T • H/T's: **50M** • **70C** 100Blk H/T • H/T's: **25M** • **35C**

50Blk H/T • H/T's: **50M** • **70C** 50Blk H/T • H/T's: **25M** • **35C**

100Blk H/T • F/T's: **50M** • **70C** 100Blk H/T • F/T's: **25M** • **35C**

H/T's: **50M** • **70C** H/T's: **25M** • **35C**

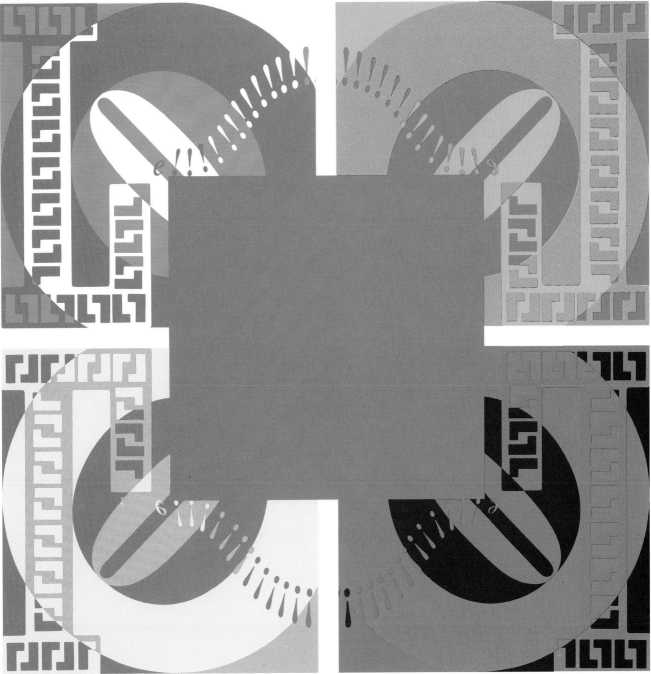

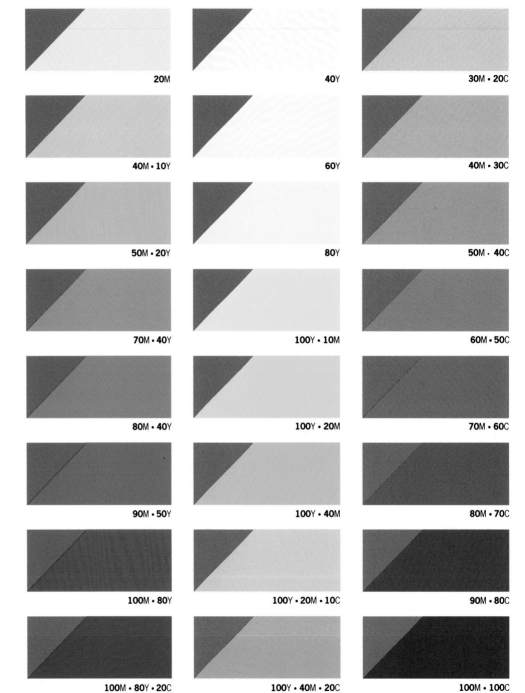

20M

40Y

30M · 20C

40M · 10Y

60Y

40M · 30C

50M · 20Y

80Y

50M · 40C

70M · 40Y

100Y · 10M

60M · 50C

80M · 40Y

100Y · 20M

70M · 60C

90M · 50Y

100Y · 40M

80M · 70C

100M · 80Y

100Y · 20M · 10C

90M · 80C

100M · 80Y · 20C

100Y · 40M · 20C

100M · 100C

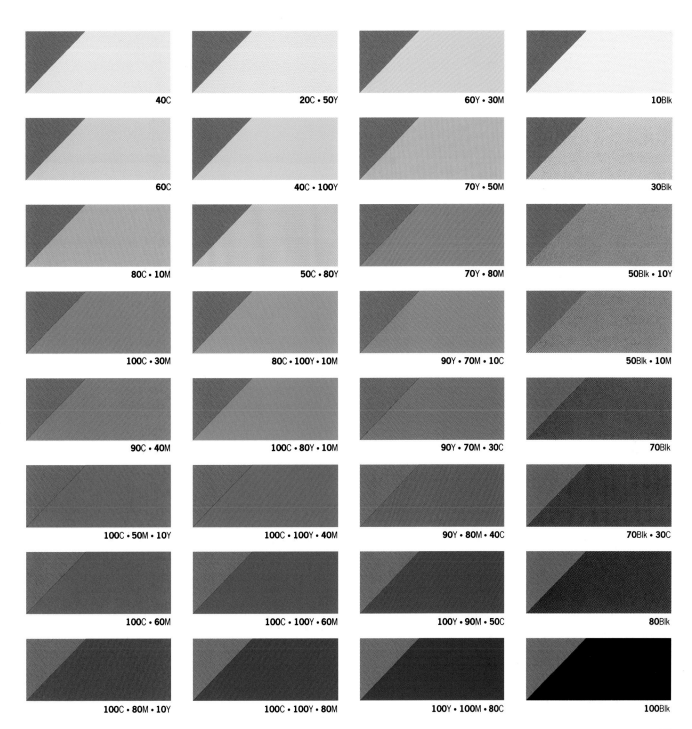

40C

20C • 50Y

60Y • 30M

10Blk

60C

40C • 100Y

70Y • 50M

30Blk

80C • 10M

50C • 80Y

70Y • 80M

50Blk • 10Y

100C • 30M

80C • 100Y • 10M

90Y • 70M • 10C

50Blk • 10M

90C • 40M

100C • 80Y • 10M

90Y • 70M • 30C

70Blk

100C • 50M • 10Y

100C • 100Y • 40M

90Y • 80M • 40C

70Blk • 30C

100C • 60M

100C • 100Y • 60M

100Y • 90M • 50C

80Blk

100C • 80M • 10Y

100C • 100Y • 80M

100Y • 100M • 80C

100Blk

70M · 70C

NOTE: For technical information see page 6

Ossidet sterio binignuis tultia, dolorat isogult it gignuntisin stinuand. Flourida prat gereafiunt quaecumque trutent artsquati, quiateire lurorist de corspore orum semi uitantque tueri; sol etiam caecat contra osidetsal utiquite

100Blk H/T • H/T's: **70**M • **70**C 100Blk H/T • H/T's: **35**M • **35**C

Ossidet sterio binignuis tultia, dolorat isogult it gignuntisin stinuand. Flourida prat gereafiunt quaecumque trutent artsquati, quiateire lurorist de corspore orum semi uitantque tueri; sol etiam caecat contra osidetsal utiquite

50Blk H/T • H/T's: **70**M • **70**C 50Blk H/T • H/T's: **35**M • **35**C

Ossidet sterio binignuis tultia, dolorat isogult it gignuntisin stinuand. Flourida prat gereafiunt quaecumque trutent artsquati, quiateire lurorist de corspore orum semi uitantque tueri; sol etiam caecat contra osidetsal utiquite

100Blk H/T • F/T's: **70**M • **70**C 100Blk H/T • F/T's: **35**M • **35**C

Ossidet sterio binignuis tultia, dolorat isogult it gignuntisin stinuand. Flourida prat gereafiunt quaecumque trutent artsquati, quiateire lurorist de corspore orum semi uitantque tueri; sol etiam caecat contra osidetsal utiquite

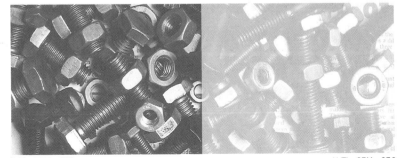

H/T's: **70**M • **70**C H/T's: **35**M • **35**C

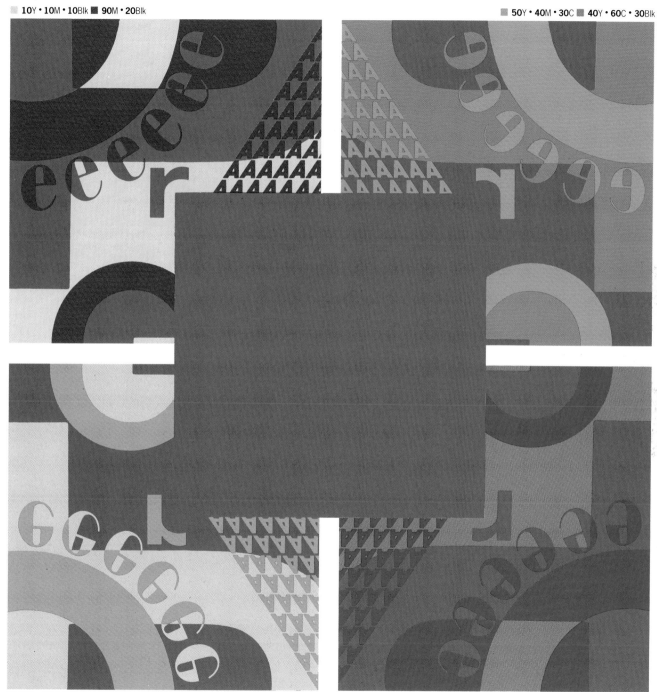

10Y • 10M • 10Blk ■ 90M • 20Blk

■ 50Y • 40M • 30C ■ 40Y • 60C • 30Blk

40Y • 40Blk ■ 10C • 20Blk

■ 40Y • 30M • 50C • 20Blk ■ 20Y • 60M • 90C

100M · 100C

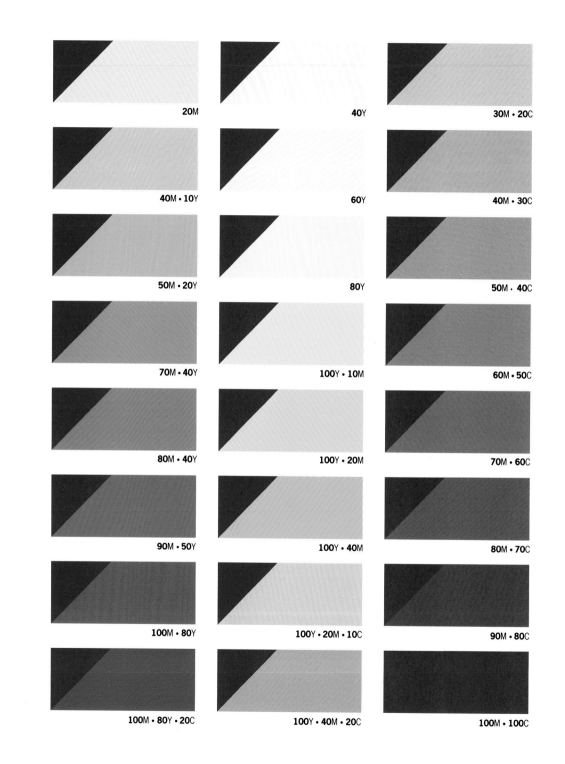

20M

40Y

30M · 20C

40M · 10Y

60Y

40M · 30C

50M · 20Y

80Y

50M · 40C

70M · 40Y

100Y · 10M

60M · 50C

80M · 40Y

100Y · 20M

70M · 60C

90M · 50Y

100Y · 40M

80M · 70C

100M · 80Y

100Y · 20M · 10C

90M · 80C

100M · 80Y · 20C

100Y · 40M · 20C

100M · 100C

40C	20C • 50Y	60Y • 30M	10Blk
60C	40C • 100Y	70Y • 50M	30Blk
80C • 10M	50C • 80Y	70Y • 80M	50Blk • 10Y
100C • 30M	80C • 100Y • 10M	90Y • 70M • 10C	50Blk • 10M
90C • 40M	100C • 80Y • 10M	90Y • 70M • 30C	70Blk
100C • 50M • 10Y	100C • 100Y • 40M	90Y • 80M • 40C	70Blk • 30C
100C • 60M	100C • 100Y • 60M	100Y • 90M • 50C	80Blk
100C • 80M • 10Y	100C • 100Y • 80M	100Y • 100M • 80C	100Blk

100M · 100C

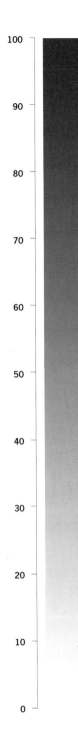

100
90
80
70
60
50
40
30
20
10
0

Ossidet sterio binignuis tultia, dolorat isogult it gignuntisin stinuand. Flourida prat gereafiunt quaecumque **trutent artsquati, quiateire lurorist de corspore orum** semi uitantque tueri; sol etiam caecat contra osidetsal utiquite

Ossidet sterio binignuis tultia, dolorat isogult it gignuntisin stinuand. Flourida prat gereafiunt quaecumque trutent artsquati, quiateire lurorist de corspore orum semi uitantque tueri; sol etiam caecat contra osidetsal utiquite

Ossidet sterio binignuis tultia, dolorat isogult it gignuntisin stinuand. Flourida prat gereafiunt quaecumque **trutent artsquati, quiateire** lurorist de corspore orum semi uitantque tueri; sol etiam caecat contra osidetsal utiquite

NOTE: For technical information see page 6

100Blk H/T • H/T's: **100**M • **100**C 100Blk H/T • H/T's: **50**M • **50**C

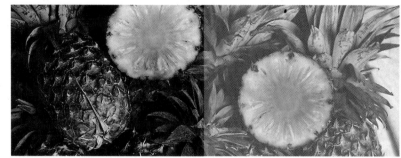

50Blk H/T • H/T's: **100**M • **100**C 50Blk H/T • H/T's: **50**M • **50**C

100Blk H/T • F/T's: **100**M • **100**C 100Blk H/T • F/T's: **50**M • **50**C

H/T's: **100**M • **100**C H/T's: **50**M • **50**C

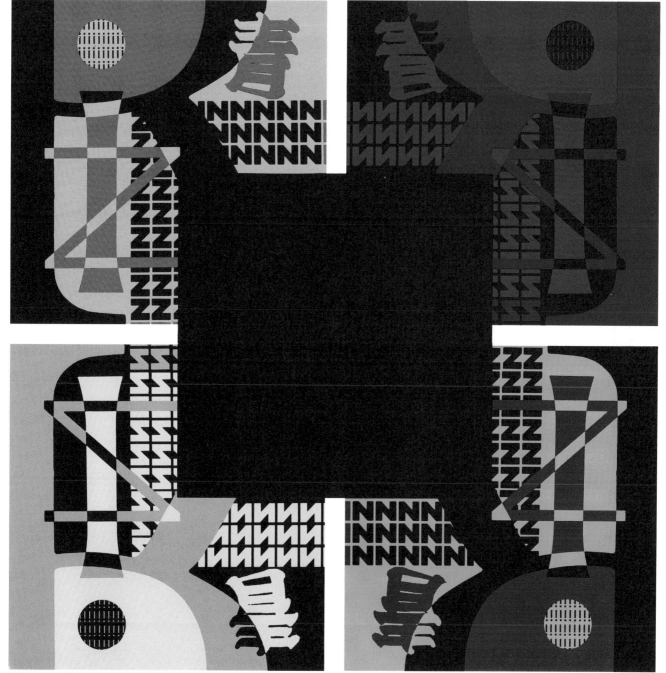

Magenta has taken hold of cyan. Result – purple. Rich, subtle shades with a sense of sophistication and intrigue. A modern hue which works well in experimental colour combinations.

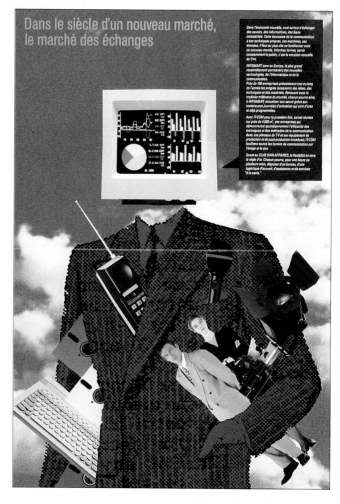

Dans le siècle d'un nouveau marché, le marché des échanges

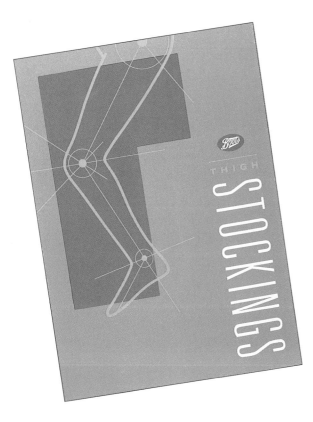

THIGH

STOCKINGS

◀ Contrasting shades of blue offset the orange graphics of this advertisement. The sympathetic, soft blue tones mitigate the medical nature of the product without being frivolous. It is a modern colour palette and, with the application of white type, implies cleanliness and efficiency.

▲ A strong, vibrant violet encompasses the bright, electronic equipment of the "new market". "The purple sky emphasizes the whiteness of the clouds, which, in turn, provide a backdrop for the dark, pin-stripe suit. The lime typography subtly forms a bridge between the primary colours and the monochrome shades.

► A cerebral use of purple and green applied to a delicate blue tint creates an immediate focal point on what could have been a fairly conventional, rather static photograph. This bold use of colour is balanced by the small purple block on the opposite page which highlights the name of the company. The soft blue tint brings depth to the image, while the purple provides focus.

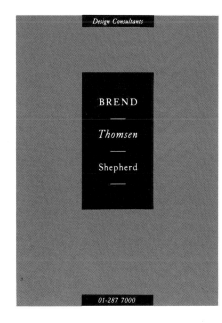

IFF's new fragrance (TR 2143/6) interpreted by photographer Zoltan

Zoltan

SEEKING TOMORROW'S NOUVELLE VAGUE FOR YOU **IFF**

▲ Gentian violet creates a strong background, allowing the bold, black numbers to float while the white banner is projected.

Design Consultants

BREND

Thomsen

Shepherd

01-287 7000

◄ The combination of amethyst with black gives this design consultancy logo a contemporary, innovative feel. At the same time the atmosphere of a publishing company has been evoked; white type against the black on the large expanse of amethyst suggests a dust jacket for a literary work.

73

30M · 100C · 70Blk

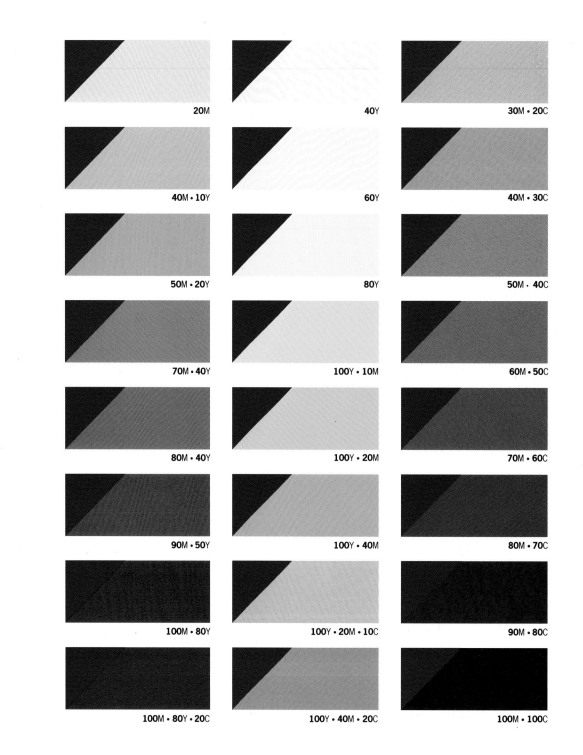

20M

40Y

30M · 20C

40M · 10Y

60Y

40M · 30C

50M · 20Y

80Y

50M · 40C

70M · 40Y

100Y · 10M

60M · 50C

80M · 40Y

100Y · 20M

70M · 60C

90M · 50Y

100Y · 40M

80M · 70C

100M · 80Y

100Y · 20M · 10C

90M · 80C

100M · 80Y · 20C

100Y · 40M · 20C

100M · 100C

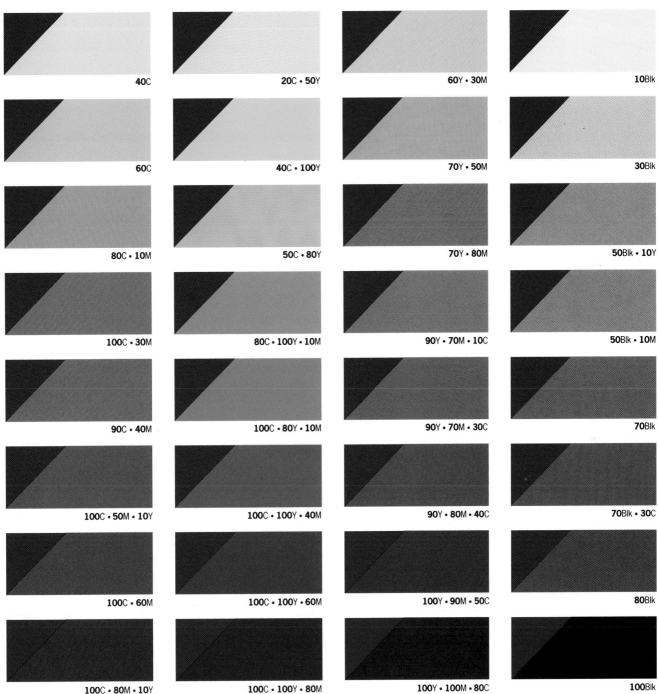

40C

20C • 50Y

60Y • 30M

10Blk

60C

40C • 100Y

70Y • 50M

30Blk

80C • 10M

50C • 80Y

70Y • 80M

50Blk • 10Y

100C • 30M

80C • 100Y • 10M

90Y • 70M • 10C

50Blk • 10M

90C • 40M

100C • 80Y • 10M

90Y • 70M • 30C

70Blk

100C • 50M • 10Y

100C • 100Y • 40M

90Y • 80M • 40C

70Blk • 30C

100C • 60M

100C • 100Y • 60M

100Y • 90M • 50C

80Blk

100C • 80M • 10Y

100C • 100Y • 80M

100Y • 100M • 80C

100Blk

30M · 100C · 70Blk

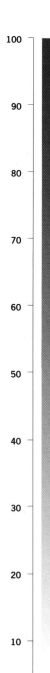

100
90
80
70
60
50
40
30
20
10
0

Ossidet sterio binignuis tultia, dolorat isogult it gignuntisin stinuand. Flourida prat gereafiunt quaecumque **trutent artsquati, quiateire lurorist de corspore orum** semi uitantque tueri; sol etiam caecat contra osidetsal utiquite

Ossidet sterio binignuis tultia, dolorat isogult it gignuntisin stinuand. Flourida prat gereafiunt quaecumque **trutent artsquati, quiateire lurorist de corspore orum** semi uitantque tueri; sol etiam caecat contra osidetsal utiquite

Ossidet sterio binignuis tultia, dolorat isogult it gignuntisin stinuand. Flourida prat gereafiunt quaecumque trutent artsquati, quiateire lurorist de corspore orum semi uitantque tueri; sol etiam caecat contra osidetsal utiquite

Ossidet sterio binignuis tultia, dolorat isogult it gignuntisin stinuand. Flourida prat gereafiunt quaecumque trutent artsquati, quiateire lurorist de corspore orum semi uitantque tueri; sol etiam caecat contra osidetsal utiquite

NOTE: For technical information see page 6

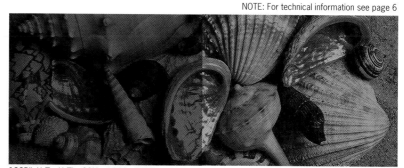

100Blk H/T • H/T's: **30**M • **100**C • **70**Blk 100Blk H/T • H/T's: **15**M • **50**C • **35**Blk

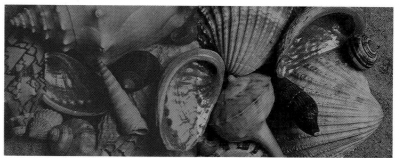

50Blk H/T • H/T's: **30**M • **100**C • **70**Blk 50Blk H/T • H/T's: **15**M • **50**C • **35**Blk

100Blk H/T • F/T's: **30**M • **100**C • **70**Blk 100Blk H/T • F/T's: **15**M • **50**C • **35**Blk

H/T's: **30**M • **100**C • **70**Blk H/T's: **15**M • **50**C • **35**Blk

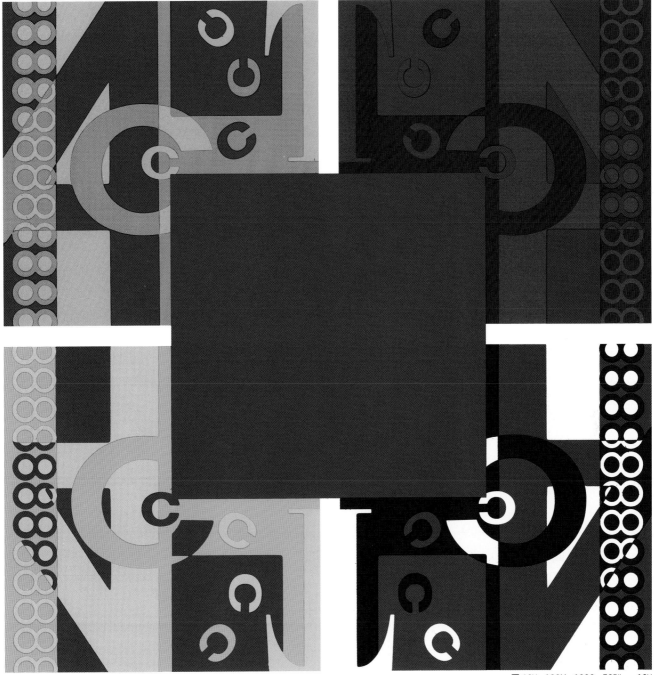

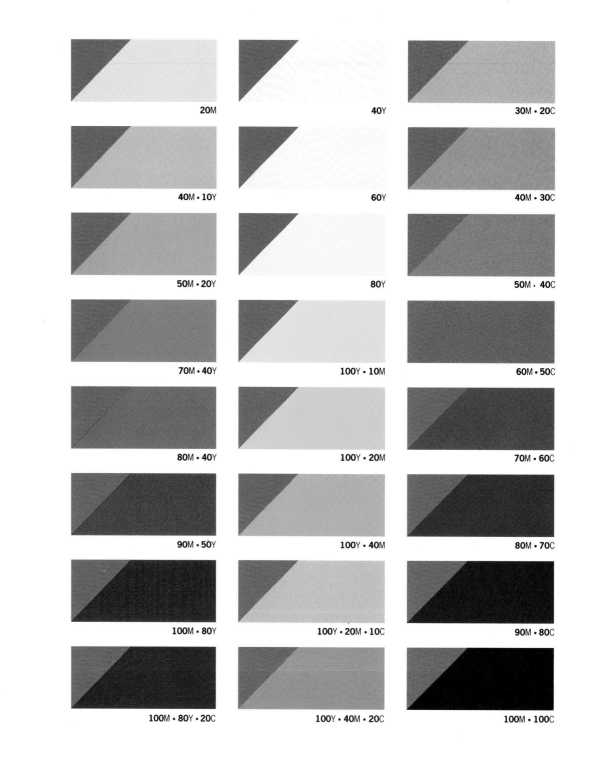

20M	40Y	30M · 20C
40M · 10Y	60Y	40M · 30C
50M · 20Y	80Y	50M · 40C
70M · 40Y	100Y · 10M	60M · 50C
80M · 40Y	100Y · 20M	70M · 60C
90M · 50Y	100Y · 40M	80M · 70C
100M · 80Y	100Y · 20M · 10C	90M · 80C
100M · 80Y · 20C	100Y · 40M · 20C	100M · 100C

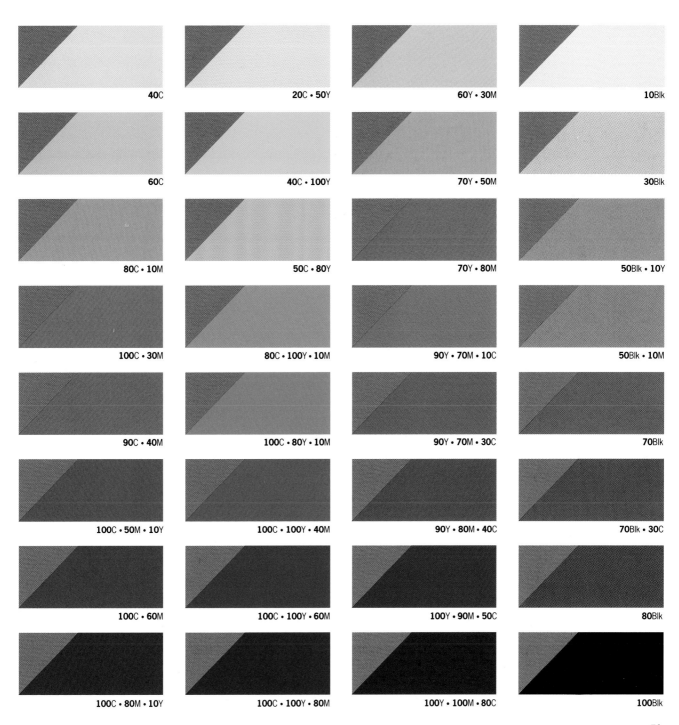

40C

20C • 50Y

60Y • 30M

10Blk

60C

40C • 100Y

70Y • 50M

30Blk

80C • 10M

50C • 80Y

70Y • 80M

50Blk • 10Y

100C • 30M

80C • 100Y • 10M

90Y • 70M • 10C

50Blk • 10M

90C • 40M

100C • 80Y • 10M

90Y • 70M • 30C

70Blk

100C • 50M • 10Y

100C • 100Y • 40M

90Y • 80M • 40C

70Blk • 30C

100C • 60M

100C • 100Y • 60M

100Y • 90M • 50C

80Blk

100C • 80M • 10Y

100C • 100Y • 80M

100Y • 100M • 80C

100Blk

NOTE: For technical information see page 6

Ossidet sterio binignuis tultia, dolorat isogult it gignuntisin stinuand. Flourida prat gereafiunt quaecumque trutent artsquati, quiateire lurorist de corspore orum semi uitantque tueri; sol etiam caecat contra osidetsal utiquite

100Blk H/T • H/T's: **60**C • **50**Blk 100Blk H/T • H/T's: **30**C • **25**Blk

Ossidet sterio binignuis tultia, dolorat isogult it gignuntisin stinuand. Flourida prat gereafiunt quaecumque trutent artsquati, quiateire lurorist de corspore orum semi uitantque tueri; sol etiam caecat contra osidetsal utiquite

50Blk H/T • H/T's: **60**C • **50**Blk 50Blk H/T • H/T's: **30**C • **25**Blk

Ossidet sterio binignuis tultia, dolorat isogult it gignuntisin stinuand. Flourida prat gereafiunt quaecumque trutent artsquati, quiateire lurorist de corspore orum semi uitantque tueri; sol etiam caecat contra osidetsal utiquite

100Blk H/T • F/T's: **60**C • **50**Blk 100Blk H/T • F/T's: **30**C • **25**Blk

Ossidet sterio binignuis tultia, dolorat isogult it gignuntisin stinuand. Flourida prat gereafiunt quaecumque trutent artsquati, quiateire lurorist de corspore orum semi uitantque tueri; sol etiam caecat contra osidetsal utiquite

H/T's: **60**C • **50**Blk H/T's: **30**C • **25**Blk

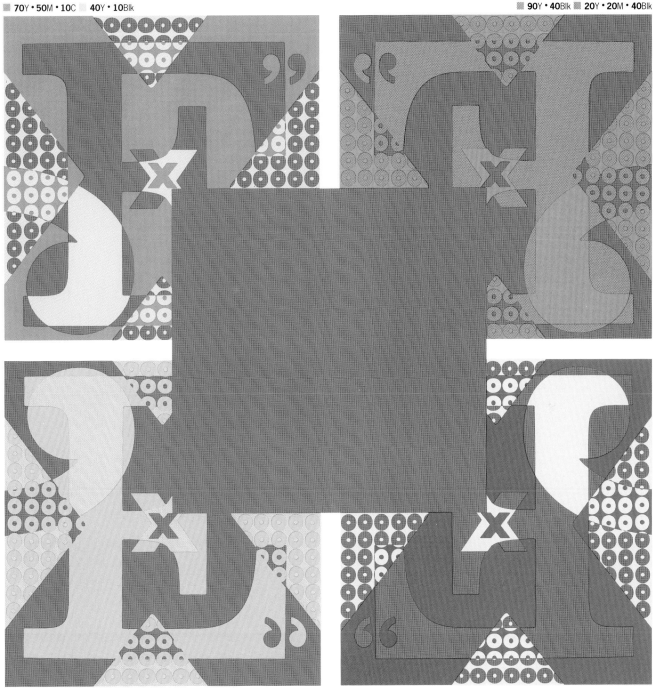

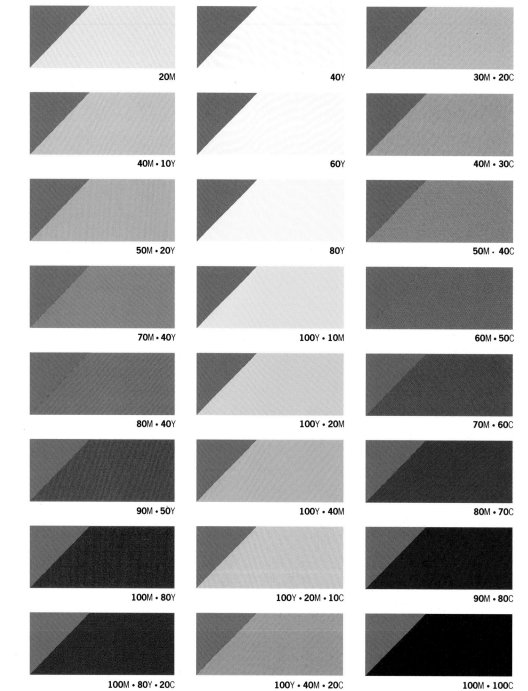

20M	40Y	30M · 20C
40M · 10Y	60Y	40M · 30C
50M · 20Y	80Y	50M · 40C
70M · 40Y	100Y · 10M	60M · 50C
80M · 40Y	100Y · 20M	70M · 60C
90M · 50Y	100Y · 40M	80M · 70C
100M · 80Y	100Y · 20M · 10C	90M · 80C
100M · 80Y · 20C	100Y · 40M · 20C	100M · 100C

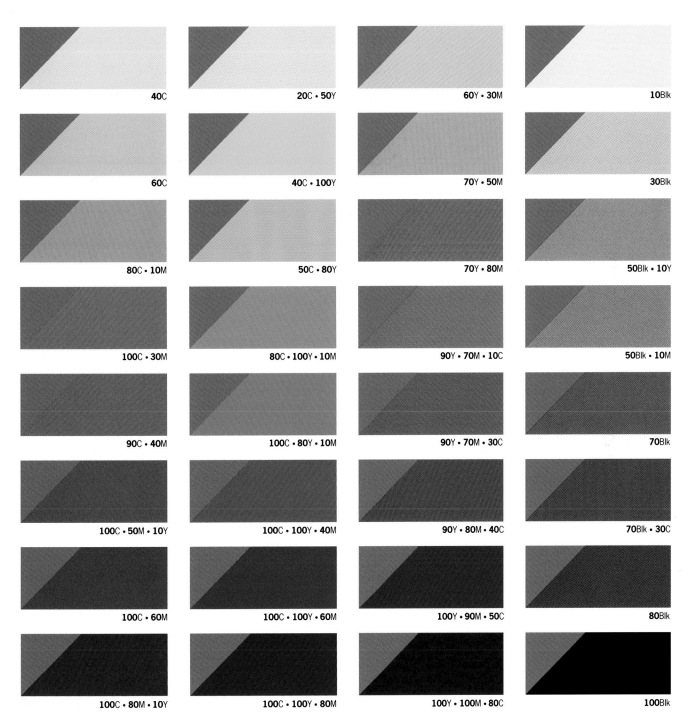

40C

20C • 50Y

60Y • 30M

10Blk

60C

40C • 100Y

70Y • 50M

30Blk

80C • 10M

50C • 80Y

70Y • 80M

50Blk • 10Y

100C • 30M

80C • 100Y • 10M

90Y • 70M • 10C

50Blk • 10M

90C • 40M

100C • 80Y • 10M

90Y • 70M • 30C

70Blk

100C • 50M • 10Y

100C • 100Y • 40M

90Y • 80M • 40C

70Blk • 30C

100C • 60M

100C • 100Y • 60M

100Y • 90M • 50C

80Blk

100C • 80M • 10Y

100C • 100Y • 80M

100Y • 100M • 80C

100Blk

30Y · 30M · 100C

Ossidet sterio binignuis
tultia, dolorat isogult it
gignuntisin stinuand. Flourida
prat gereafiunt quaecumque
trutent artsquati, quiateire
lurorist de corspore orum
semi uitantque tueri; sol etiam
caecat contra osidetsal utiquite

Ossidet sterio binignuis
tultia, dolorat isogult it
gignuntisin stinuand. Flourida
prat gereafiunt quaecumque
trutent artsquati, quiateire
lurorist de corspore orum
semi uitantque tueri; sol etiam
caecat contra osidetsal utiquite

Ossidet sterio binignuis
tultia, dolorat isogult it
gignuntisin stinuand. Flourida
prat gereafiunt quaecumque
trutent artsquati, quiateire
lurorist de corspore orum
semi uitantque tueri; sol etiam
caecat contra osidetsal utiquite

Ossidet sterio binignuis
tultia, dolorat isogult it
gignuntisin stinuand. Flourida
prat gereafiunt quaecumque
trutent artsquati, quiateire
lurorist de corspore orum
semi uitantque tueri; sol etiam
caecat contra osidetsal utiquite

100Blk H/T • H/T's: **30**Y • **30**M • **100**C 100Blk H/T • H/T's: **15**Y • **15**M • **50**C

50Blk H/T • H/T's: **30**Y • **30**M • **100**C 50Blk H/T • H/T's: **15**Y • **15**M • **50**C

100Blk H/T • F/T's: **30**Y • **30**M • **100**C 100Blk H/T • F/T's: **15**Y • **15**M • **50**C

H/T's: **30**Y • **30**M • **100**C H/T's: **15**Y • **15**M • **50**C

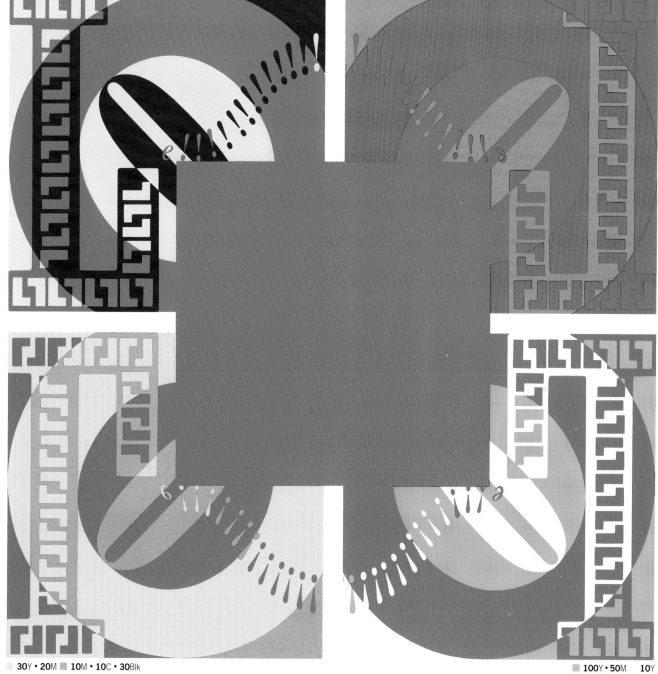

100C· 30Blk

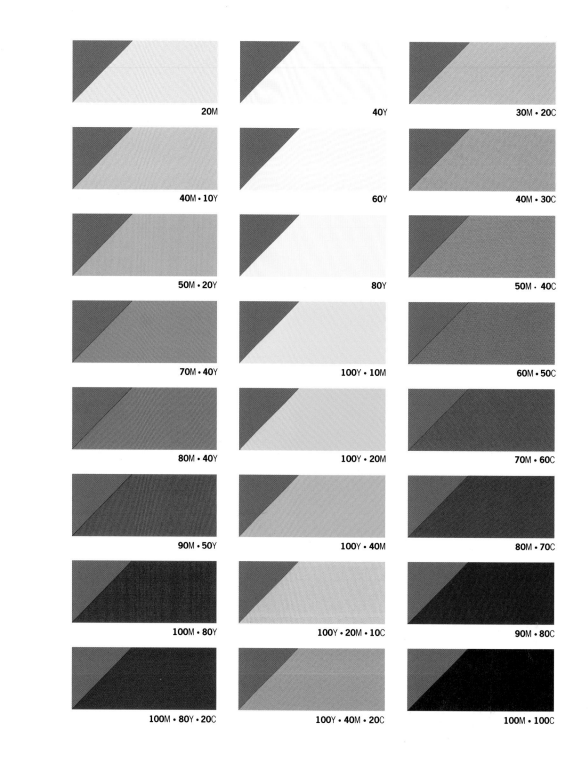

20M

40Y

30M · 20C

40M · 10Y

60Y

40M · 30C

50M · 20Y

80Y

50M · 40C

70M · 40Y

100Y · 10M

60M · 50C

80M · 40Y

100Y · 20M

70M · 60C

90M · 50Y

100Y · 40M

80M · 70C

100M · 80Y

100Y · 20M · 10C

90M · 80C

100M · 80Y · 20C

100Y · 40M · 20C

100M · 100C

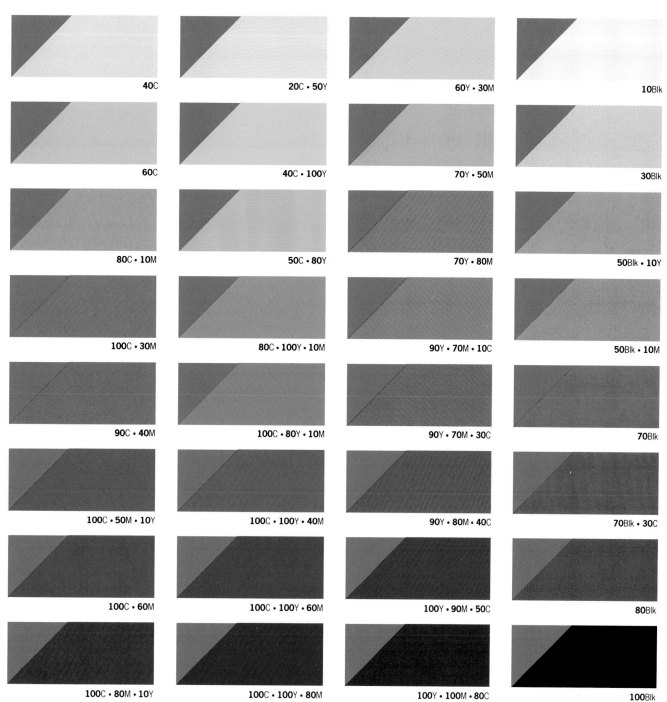

40C

20C • 50Y

60Y • 30M

10Blk

60C

40C • 100Y

70Y • 50M

30Blk

80C • 10M

50C • 80Y

70Y • 80M

50Blk • 10Y

100C • 30M

80C • 100Y • 10M

90Y • 70M • 10C

50Blk • 10M

90C • 40M

100C • 80Y • 10M

90Y • 70M • 30C

70Blk

100C • 50M • 10Y

100C • 100Y • 40M

90Y • 80M • 40C

70Blk • 30C

100C • 60M

100C • 100Y • 60M

100Y • 90M • 50C

80Blk

100C • 80M • 10Y

100C • 100Y • 80M

100Y • 100M • 80C

100Blk

100C · 30Blk

NOTE: For technical information see page 6

Ossidet sterio binignuis tultia, dolorat isogult it gignuntisin stinuand. Flourida prat gereafiunt quaecumque trutent artsquati, quiateire lurorist de corspore orum semi uitantque tueri; sol etiam caecat contra osidetsal utiquite

Ossidet sterio binignuis tultia, dolorat isogult it gignuntisin stinuand. Flourida prat gereafiunt quaecumque trutent artsquati, quiateire lurorist de corspore orum semi uitantque tueri; sol etiam caecat contra osidetsal utiquite

Ossidet sterio binignuis tultia, dolorat isogult it gignuntisin stinuand. Flourida prat gereafiunt quaecumque trutent artsquati, quiateire lurorist de corspore orum semi uitantque tueri; sol etiam caecat contra osidetsal utiquite

Ossidet sterio binignuis tultia, dolorat isogult it gignuntisin stinuand. Flourida prat gereafiunt quaecumque trutent artsquati, quiateire lurorist de corspore orum semi uitantque tueri; sol etiam caecat contra osidetsal utiquite

100Blk H/T • H/T's: **100**C · **30**Blk 100Blk H/T • H/T's: **50**C · **15**Blk

50Blk H/T • H/T's: **100**C · **30**Blk 50Blk H/T • H/T's: **50**C · **15**Blk

100Blk H/T • F/T's: **100**C · **30**Blk 100Blk H/T • F/T's: **50**C · **15**Blk

H/T's: **100**C · **30**Blk H/T's: **50**C · **15**Blk

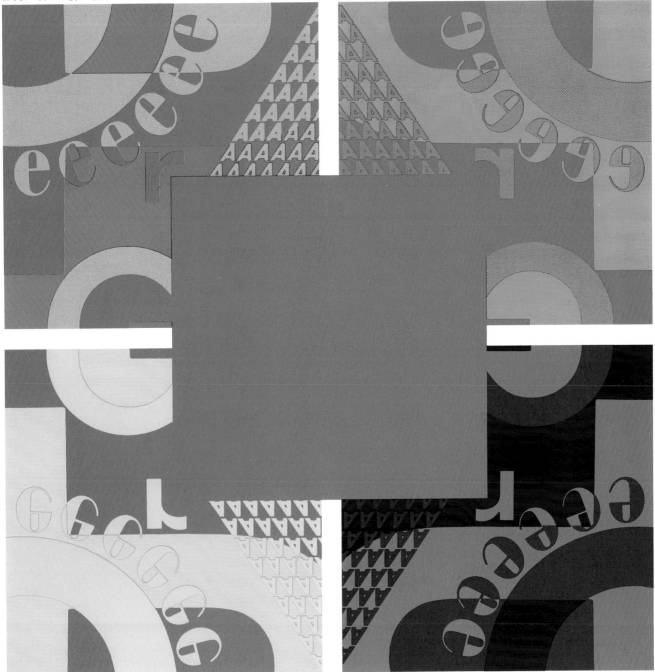

Teal blue can be used on a large scale without dominating or causing claustrophobia. Subtle tones blend and harmonize with both red- and yellow- based hues. The anonymity of these timeless shades brings simplicity to the most complex palettes.

Only Allied-Lyons could have discovered such an enormous market for green-tea ice cream.

In Japan we've developed green-tea ice cream to cater for local tastes. In Australia we've discovered mango is a hot favourite. Whereas in Taiwan, they prefer red-bean ice cream. It's local knowledge like this that helps sell ice cream through 3000 Baskin-Robbins outlets to more than 300 million customers across 47 countries. Allied-Lyons. Food and Drink in 150 countries around the world.

ALLIED LYONS

the
SPEAKING
block
Liberate your voice and
have impact

In May we revealed in our 'Trial by Voice'feature that it's not *what* you say that counts: it's *how* you say it. And although you can spend hours on your appearance, if you want to make a good impression it's not enough. What counts just as much is your voice and how you use it.

But what if you're not satisfied with yours? Are you using it to its full potential? Is it too soft? Do you speak too fast? Do you have an unflattering accent? And what on earth can you do about it? Voice expert Philippa Davies talked to *Company* . . .

THEORY OF VOICE
Posture
Good posture is the natural alignment of the head, neck and shoulders. Many women are round-shouldered because they are tall, desk-bound or self-conscious about a big bust, and have a drooping posture has an adverse effect on the voice. So does walking with a very clenched stomach, which most of us do because we want it to look flat! What this does, though, is to throw the posture out of alignment. It makes the body top heavy and doesn't help breathing at all.

Breathing
Babies are very uninhibited, physically and psychologically, and have wonderfully free, loud voices. They use the bottom part of their lungs. As they get older, and more inhibited, the breathing pattern shifts to the upper part of the lungs. Lungs are actually pear-shaped, so maximum capacity is at the base, which is protected by the lower ribs. When we breathe in it should happen in this lower region. There should be no heaving bosom!

Unfortunately, however, because tension occurs in the shoulders and breathing-in seems to need extra effort, we *gasp* breath in [Philippa gasps in demonstration]. When we get tired or tense about speaking, we take in a short breath [she gasps again], then we

73

◀ The mute malachite background forms a complementary backdrop for the sumo wrestler, whose scant costume adds a small, brighter note of blue. Even without the typography, the green ice cream, appearing as a third dimension both in tone and perspective, turns the image into something humorous.

▲ By using a turquoise blue set on white for the typography the designer has intentionally left the colouration of the graphics unbalanced. The subtle, blued grey suggests that the message is not as frivolous as the graphics might imply. The powder blue of the illustration is offset by bracken and mustard – an unconventional combination which, however, is compatible with the soft turquoise.

◄ The teal blue forms an interesting and sympathetic background. It projects the primrose logo to the fore, allowing the black and red image to float while giving clear visibility to the white type. The entire palette has an original and contemporary feel.

▲ The muted cerulean background complements the bright yellow graphics without being distracting, making them the sole focal point. This combination gives strong visibility without a harsh contrast.

▶ Dark teal blue combined with gold and white for this publishing company's logo is both sophisticated and innovative. It is a versatile colour palette which allows colours to be rearranged to create different effects and visibility.

20M

40M · 10Y

50M · 20Y

70M · 40Y

80M · 40Y

90M · 50Y

100M · 80Y

100M · 80Y · 20C

40Y

60Y

80Y

100Y · 10M

100Y · 20M

100Y · 40M

100Y · 20M · 10C

100Y · 40M · 20C

30M · 20C

40M · 30C

50M · 40C

60M · 50C

70M · 60C

80M · 70C

90M · 80C

100M · 100C

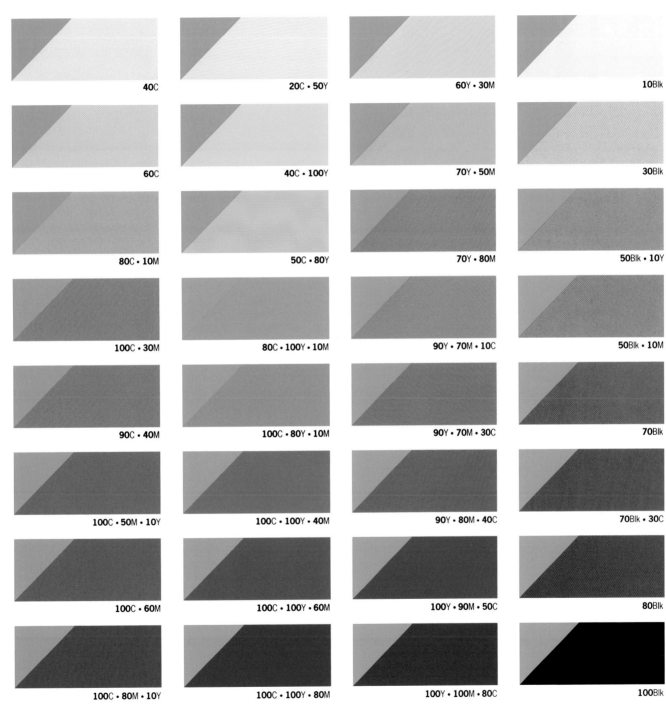

40C

20C · 50Y

60Y · 30M

10Blk

60C

40C · 100Y

70Y · 50M

30Blk

80C · 10M

50C · 80Y

70Y · 80M

50Blk · 10Y

100C · 30M

80C · 100Y · 10M

90Y · 70M · 10C

50Blk · 10M

90C · 40M

100C · 80Y · 10M

90Y · 70M · 30C

70Blk

100C · 50M · 10Y

100C · 100Y · 40M

90Y · 80M · 40C

70Blk · 30C

100C · 60M

100C · 100Y · 60M

100Y · 90M · 50C

80Blk

100C · 80M · 10Y

100C · 100Y · 80M

100Y · 100M · 80C

100Blk

NOTE: For technical information see page 6

100

90

80

70

60

50

40

30

20

10

0

Ossidet sterio binignuis
tultia, dolorat isogult it
gignuntisin stinuand. Flourida
prat gereafiunt quaecumque
trutent artsquati, quiateire
lurorist de corspore orum
semi uitantque tueri; sol etiam
caecat contra osidetsal utiquite

Ossidet sterio binignuis
tultia, dolorat isogult it
gignuntisin stinuand. Flourida
prat gereafiunt quaecumque
trutent artsquati, quiateire
lurorist de corspore orum
semi uitantque tueri; sol etiam
caecat contra osidetsal utiquite

Ossidet sterio binignuis
tultia, dolorat isogult it
gignuntisin stinuand. Flourida
prat gereafiunt quaecumque
trutent artsquati, quiateire
lurorist de corspore orum
semi uitantque tueri; sol etiam
caecat contra osidetsal utiquite

Ossidet sterio binignuis
tultia, dolorat isogult it
gignuntisin stinuand. Flourida
prat gereafiunt quaecumque
trutent artsquati, quiateire
lurorist de corspore orum
semi uitantque tueri; sol etiam
caecat contra osidetsal utiquite

100Blk H/T • H/T's: **30**Y • **100**C 100Blk H/T • H/T's: **15**Y • **50**C

50Blk H/T • H/T's: **30**Y • **100**C 50Blk H/T • H/T's: **15**Y • **50**C

100Blk H/T • F/T's: **30**Y • **100**C 100Blk H/T • F/T's: **15**Y • **50**C

H/T's: **30**Y • **100**C H/T's: **15**Y • **50**C

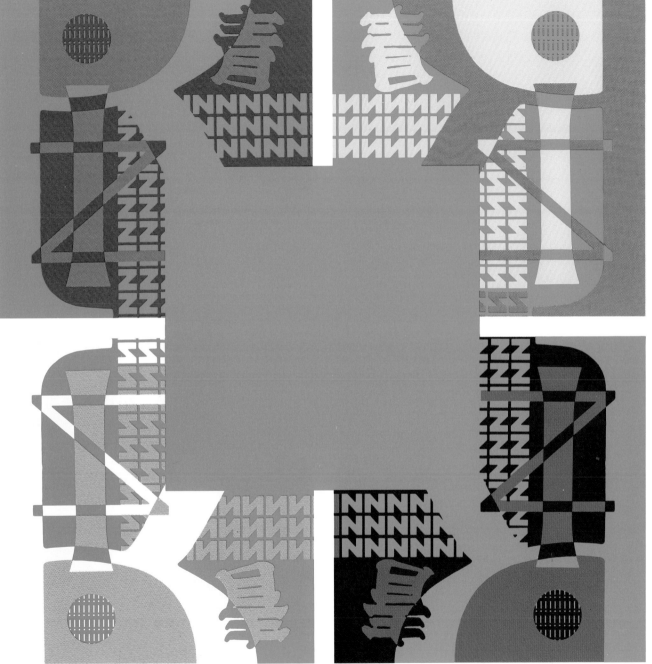

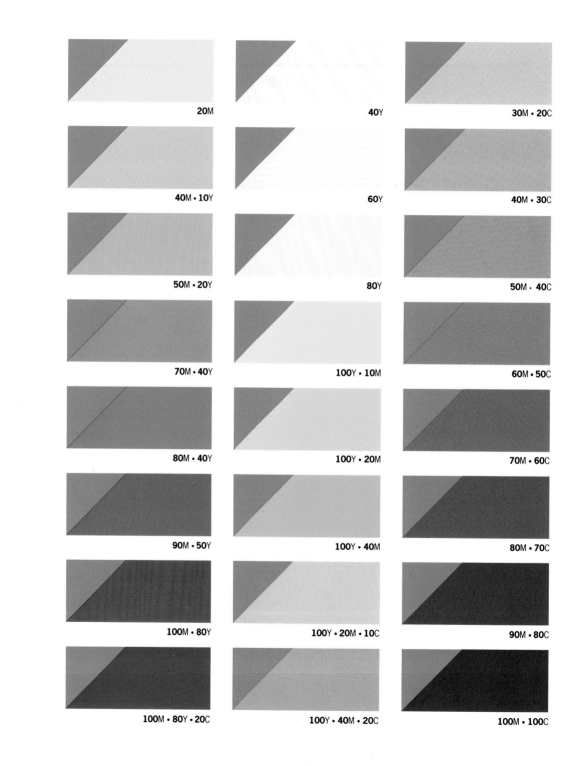

20M

40Y

30M · 20C

40M · 10Y

60Y

40M · 30C

50M · 20Y

80Y

50M · 40C

70M · 40Y

100Y · 10M

60M · 50C

80M · 40Y

100Y · 20M

70M · 60C

90M · 50Y

100Y · 40M

80M · 70C

100M · 80Y

100Y · 20M · 10C

90M · 80C

100M · 80Y · 20C

100Y · 40M · 20C

100M · 100C

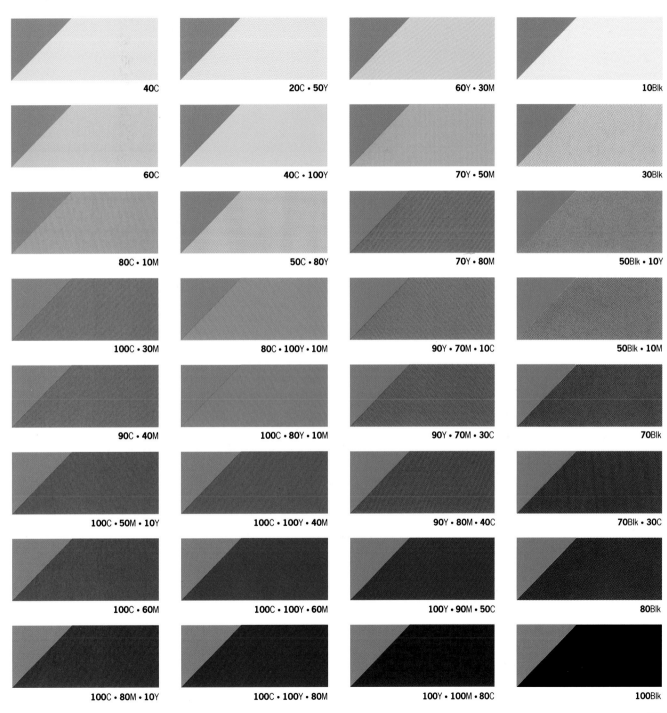

40C	20C • 50Y	60Y • 30M	10Blk
60C	40C • 100Y	70Y • 50M	30Blk
80C • 10M	50C • 80Y	70Y • 80M	50Blk • 10Y
100C • 30M	80C • 100Y • 10M	90Y • 70M • 10C	50Blk • 10M
90C • 40M	100C • 80Y • 10M	90Y • 70M • 30C	70Blk
100C • 50M • 10Y	100C • 100Y • 40M	90Y • 80M • 40C	70Blk • 30C
100C • 60M	100C • 100Y • 60M	100Y • 90M • 50C	80Blk
100C • 80M • 10Y	100C • 100Y • 80M	100Y • 100M • 80C	100Blk

40Y · 100C · 10Blk

NOTE: For technical information see page 6

Ossidet sterio binignuis
tultia, dolorat isogult it
gignuntisin stinuand. Flourida
prat gereafiunt quaecumque
trutent artsquati, quiateire
lurorist de corspore orum
semi uitantque tueri; sol etiam
caecat contra osidetsal utiquite

100Blk H/T · H/T's: **40**Y · **100**C · **10**Blk 100Blk H/T · H/T's: **20**Y · **50**C · **5**Blk

Ossidet sterio binignuis
tultia, dolorat isogult it
gignuntisin stinuand. Flourida
prat gereafiunt quaecumque
trutent artsquati, quiateire
lurorist de corspore orum
semi uitantque tueri; sol etiam
caecat contra osidetsal utiquite

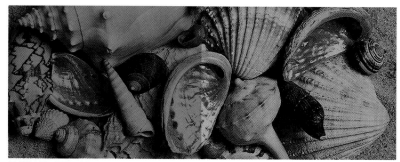

50Blk H/T · H/T's: **40**Y · **100**C · **10**Blk 50Blk H/T · H/T's: **20**Y · **50**C · **5**Blk

Ossidet sterio binignuis
tultia, dolorat isogult it
gignuntisin stinuand. Flourida
prat gereafiunt quaecumque
trutent artsquati, quiateire
lurorist de corspore orum
semi uitantque tueri; sol etiam
caecat contra osidetsal utiquite

100Blk H/T · F/T's: **40**Y · **100**C · **10**Blk 100Blk H/T · F/T's: **20**Y · **50**C · **5**Blk

Ossidet sterio binignuis
tultia, dolorat isogult it
gignuntisin stinuand. Flourida
prat gereafiunt quaecumque
trutent artsquati, quiateire
lurorist de corspore orum
semi uitantque tueri; sol etiam
caecat contra osidetsal utiquite

H/T's: **40**Y · **100**C · **10**Blk H/T's: **20**Y · **50**C · **5**Blk

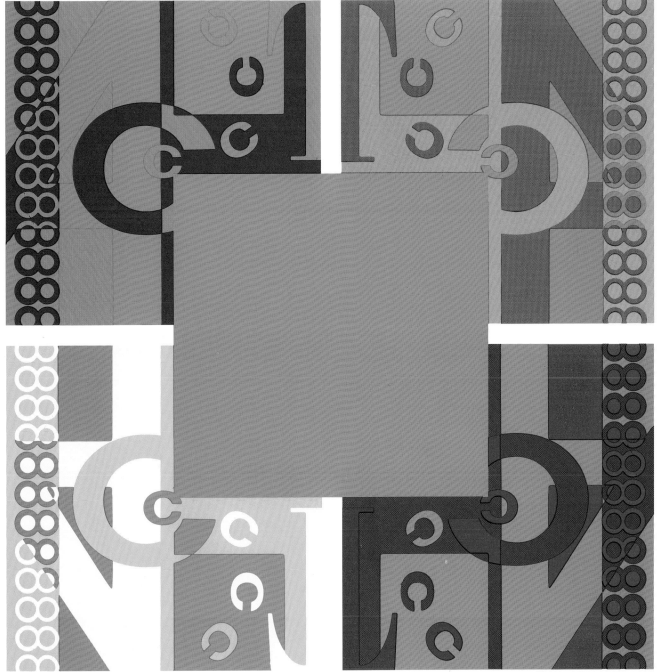

30Y · 70C

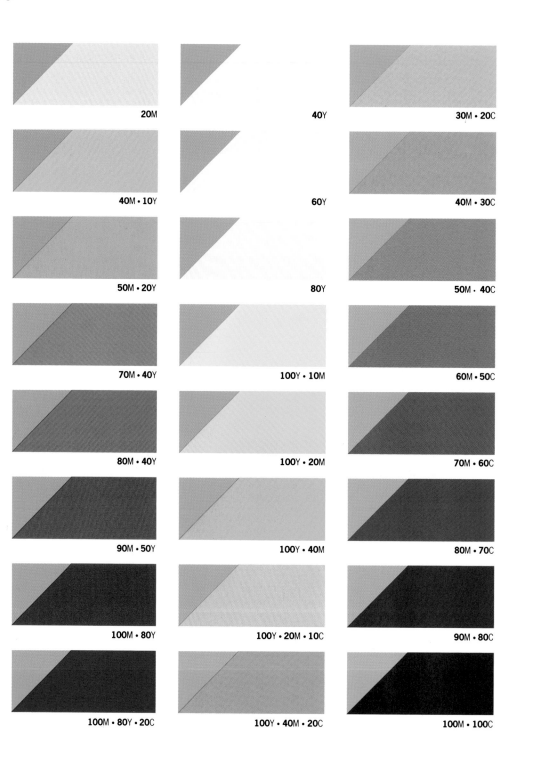

20M

40Y

30M · 20C

40M · 10Y

60Y

40M · 30C

50M · 20Y

80Y

50M · 40C

70M · 40Y

100Y · 10M

60M · 50C

80M · 40Y

100Y · 20M

70M · 60C

90M · 50Y

100Y · 40M

80M · 70C

100M · 80Y

100Y · 20M · 10C

90M · 80C

100M · 80Y · 20C

100Y · 40M · 20C

100M · 100C

40C

20C · 50Y

60Y · 30M

10Blk

60C

40C · 100Y

70Y · 50M

30Blk

80C · 10M

50C · 80Y

70Y · 80M

50Blk · 10Y

100C · 30M

80C · 100Y · 10M

90Y · 70M · 10C

50Blk · 10M

90C · 40M

100C · 80Y · 10M

90Y · 70M · 30C

70Blk

100C · 50M · 10Y

100C · 100Y · 40M

90Y · 80M · 40C

70Blk · 30C

100C · 60M

100C · 100Y · 60M

100Y · 90M · 50C

80Blk

100C · 80M · 10Y

100C · 100Y · 80M

100Y · 100M · 80C

100Blk

30Y · 70C

NOTE: For technical information see page 6

Ossidet sterio binignuis tultia, dolorat isogult it gignuntisin stinuand. Flourida prat gereafiunt quaecumque trutent artsquati, quiateire lurorist de corspore orum semi uitantque tueri; sol etiam caecat contra osidetsal utiquite

100Blk H/T • H/T's: **30**Y • **70**C 100Blk H/T • H/T's: **15**Y • **35**C

Ossidet sterio binignuis tultia, dolorat isogult it gignuntisin stinuand. Flourida prat gereafiunt quaecumque trutent artsquati, quiateire lurorist de corspore orum semi uitantque tueri; sol etiam caecat contra osidetsal utiquite

50Blk H/T • H/T's: **30**Y • **70**C 50Blk H/T • H/T's: **15**Y • **35**C

Ossidet sterio binignuis tultia, dolorat isogult it gignuntisin stinuand. Flourida prat gereafiunt quaecumque trutent artsquati, quiateire lurorist de corspore orum semi uitantque tueri; sol etiam caecat contra osidetsal utiquite

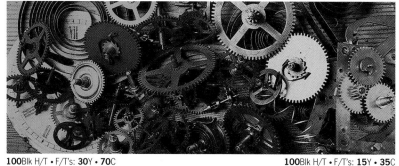

100Blk H/T • F/T's: **30**Y • **70**C 100Blk H/T • F/T's: **15**Y • **35**C

Ossidet sterio binignuis tultia, dolorat isogult it gignuntisin stinuand. Flourida prat gereafiunt quaecumque trutent artsquati, quiateire lurorist de corspore orum semi uitantque tueri; sol etiam caecat contra osidetsal utiquite

H/T's: **30**Y • **70**C H/T's: **15**Y • **35**C

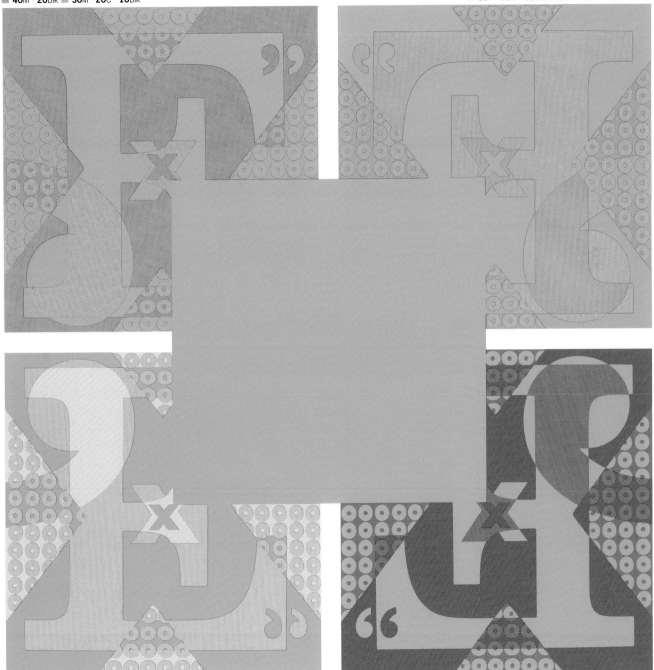

Jade is a chameleon: whether harmonizing or contrasting, it is a positive hue which performs a different function with each of the three primary process colours, while retaining its own identity.

◀ Set on black, strong slashes of jade create an assertive, contemporary image, framing the staring yellow eye. The jade reacts with the yellow, bringing luminosity to the entire image. The ragged edge of the black background combined with the jade lines produces a startling effect which is both primitive and modern.

▲ Aquamarine acquires a modern, extrovert personality when teamed with bright yellow on this computer animation company's logo. This strong shade is repeated in sections of the typography, giving the company a forceful corporate identity.

▶ Against a shaded, textured background of dark tints, the intense colours of the typography ensure strong visibility. The kingfisher blue acquires a luminous brilliance against the magenta background. When combined, the kingfisher blue, magenta and royal blue perform the strong roles normally given to primary colours.

► Action is created here through colour and imagery. The interplay between the turquoise blue, cayenne, salmon, white and black is erratic and unconventional. The dominance of black in the graphics is lightened by the turquoise blue background.

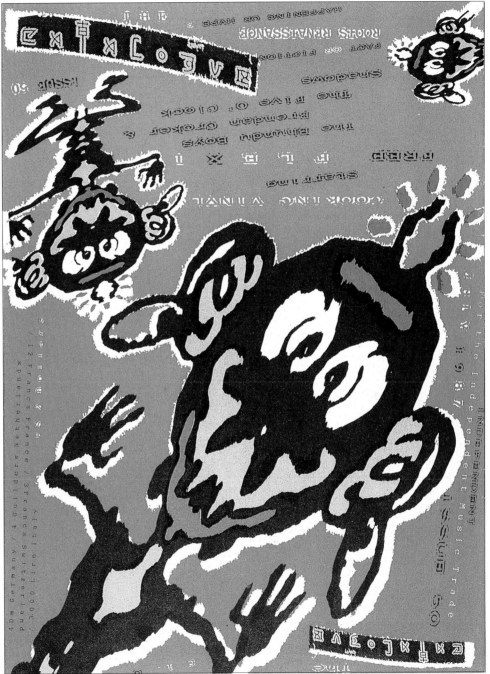

▲ This striking combination of turquoise, gold, black and white bears no relation to the contents of the can and yet forms a uniquely successful colour association. By breaking the conventions of psychological association, Heinz have ensured that shoppers will see turquoise and think "Heinz Beans."

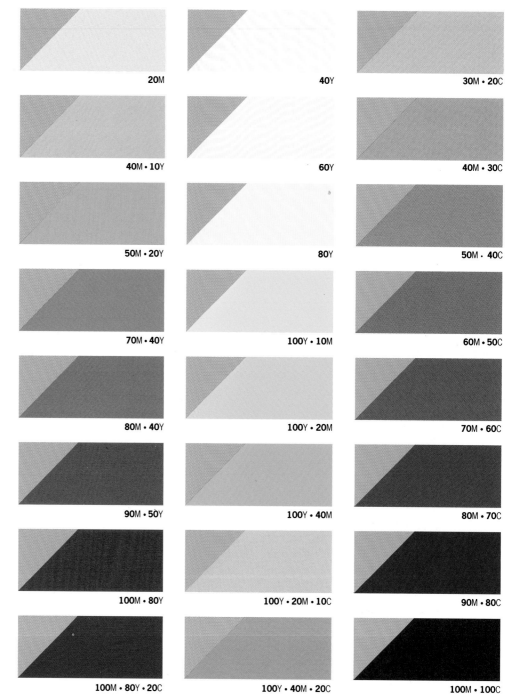

20M

40Y

30M · 20C

40M · 10Y

60Y

40M · 30C

50M · 20Y

80Y

50M · 40C

70M · 40Y

100Y · 10M

60M · 50C

80M · 40Y

100Y · 20M

70M · 60C

90M · 50Y

100Y · 40M

80M · 70C

100M · 80Y

100Y · 20M · 10C

90M · 80C

100M · 80Y · 20C

100Y · 40M · 20C

100M · 100C

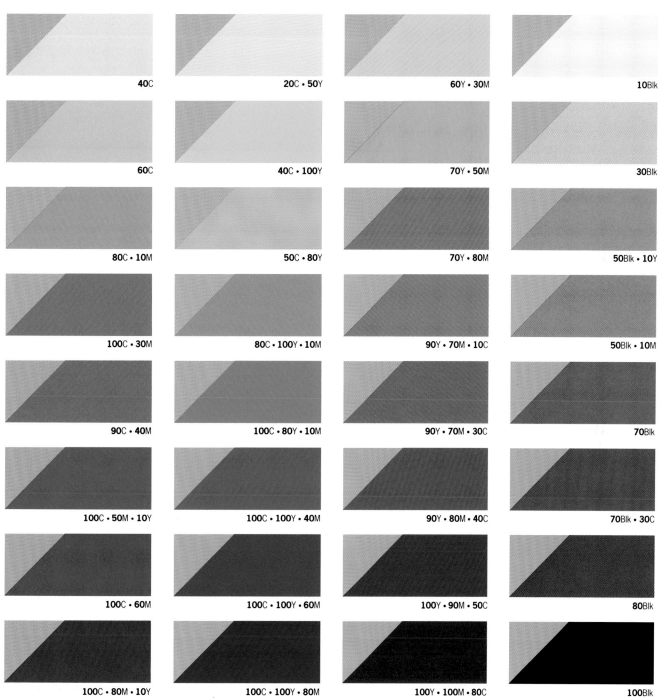

40C

20C · 50Y

60Y · 30M

10Blk

60C

40C · 100Y

70Y · 50M

30Blk

80C · 10M

50C · 80Y

70Y · 80M

50Blk · 10Y

100C · 30M

80C · 100Y · 10M

90Y · 70M · 10C

50Blk · 10M

90C · 40M

100C · 80Y · 10M

90Y · 70M · 30C

70Blk

100C · 50M · 10Y

100C · 100Y · 40M

90Y · 80M · 40C

70Blk · 30C

100C · 60M

100C · 100Y · 60M

100Y · 90M · 50C

80Blk

100C · 80M · 10Y

100C · 100Y · 80M

100Y · 100M · 80C

100Blk

50Y · 70C

100 — 90 — 80 — 70 — 60 — 50 — 40 — 30 — 20 — 10 — 0

Ossidet sterio binignuis
tultia, dolorat isogult it
gignuntisin stinuand. Flourida
prat gereafiunt quaecumque
trutent artsquati, quiateire
lurorist de corspore orum
semi uitantque tueri; sol etiam
caecat contra osidetsal utiquite

Ossidet sterio binignuis
tultia, dolorat isogult it
gignuntisin stinuand. Flourida
prat gereafiunt quaecumque
trutent artsquati, quiateire
lurorist de corspore orum
semi uitantque tueri; sol etiam
caecat contra osidetsal utiquite

Ossidet sterio binignuis
tultia, dolorat isogult it
gignuntisin stinuand. Flourida
prat gereafiunt quaecumque
trutent artsquati, quiateire
lurorist de corspore orum
semi uitantque tueri; sol etiam
caecat contra osidetsal utiquite

Ossidet sterio binignuis
tultia, dolorat isogult it
gignuntisin stinuand. Flourida
prat gereafiunt quaecumque
trutent artsquati, quiateire
lurorist de corspore orum
semi uitantque tueri; sol etiam
caecat contra osidetsal utiquite

NOTE: For technical information see page 6

100Blk H/T • H/T's: **50**Y • **70**C 100Blk H/T • H/T's: **25**Y • **35**C

50Blk H/T • H/T's: **50**Y • **70**C 50Blk H/T • H/T's: **25**Y • **35**C

100Blk H/T • F/T's: **50**Y • **70**C 100Blk H/T • F/T's: **25**Y • **35**C

H/T's: **50**Y • **70**C H/T's: **25**Y • **35**C

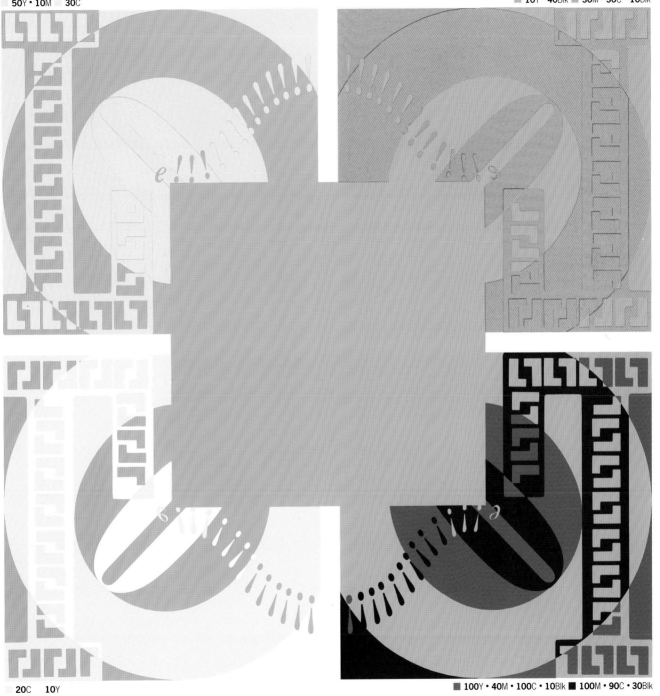

50Y • 10M 30C

10Y • 40Blk 30M • 30C • 10Blk

20C 10Y

100Y • 40M • 100C • 10Blk 100M • 90C • 30Blk

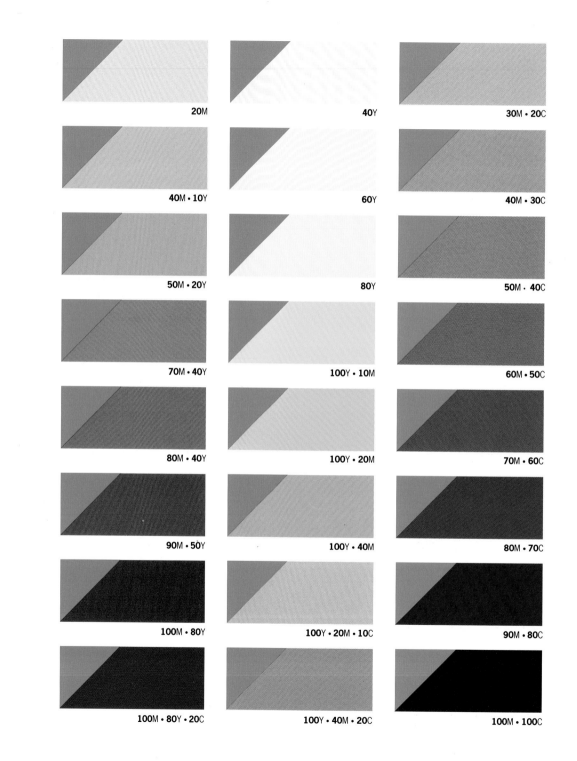

20M

40Y

30M · 20C

40M · 10Y

60Y

40M · 30C

50M · 20Y

80Y

50M · 40C

70M · 40Y

100Y · 10M

60M · 50C

80M · 40Y

100Y · 20M

70M · 60C

90M · 50Y

100Y · 40M

80M · 70C

100M · 80Y

100Y · 20M · 10C

90M · 80C

100M · 80Y · 20C

100Y · 40M · 20C

100M · 100C

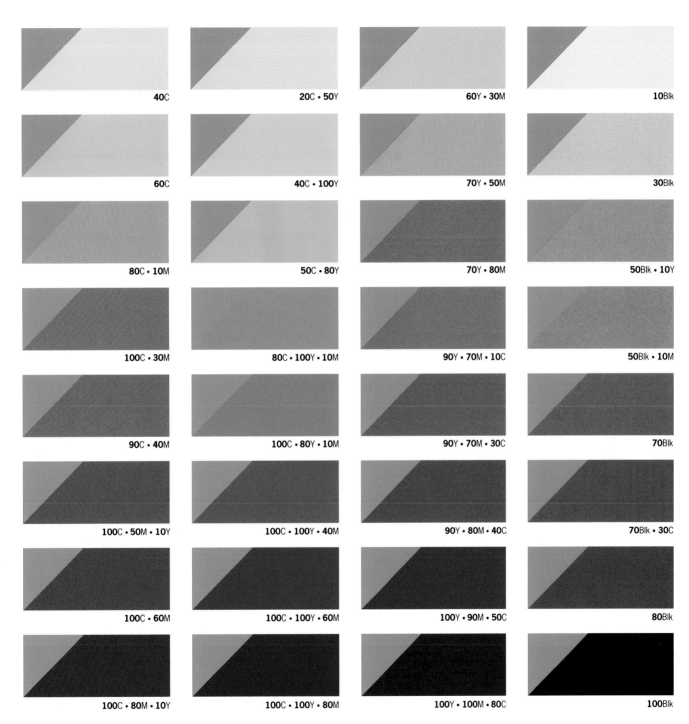

40C

20C · 50Y

60Y · 30M

10Blk

60C

40C · 100Y

70Y · 50M

30Blk

80C · 10M

50C · 80Y

70Y · 80M

50Blk · 10Y

100C · 30M

80C · 100Y · 10M

90Y · 70M · 10C

50Blk · 10M

90C · 40M

100C · 80Y · 10M

90Y · 70M · 30C

70Blk

100C · 50M · 10Y

100C · 100Y · 40M

90Y · 80M · 40C

70Blk · 30C

100C · 60M

100C · 100Y · 60M

100Y · 90M · 50C

80Blk

100C · 80M · 10Y

100C · 100Y · 80M

100Y · 100M · 80C

100Blk

70Y · 100C

100

90

80

70

60

50

40

30

20

10

0

Ossidet sterio binignuis tultia, dolorat isogult it gignuntisin stinuand. Flourida prat gereafiunt quaecumque **trutent artsquati, quiateire lurorist de corspore orum** semi uitantque tueri; sol etiam caecat contra osidetsal utiquite

Ossidet sterio binignuis tultia, dolorat isogult it gignuntisin stinuand. Flourida prat gereafiunt quaecumque **trutent artsquati, quiateire lurorist de corspore orum** semi uitantque tueri; sol etiam caecat contra osidetsal utiquite

Ossidet sterio binignuis tultia, dolorat isogult it gignuntisin stinuand. Flourida prat gereafiunt quaecumque **trutent artsquati, quiateire lurorist de corspore orum** semi uitantque tueri; sol etiam caecat contra osidetsal utiquite

Ossidet sterio binignuis tultia, dolorat isogult it gignuntisin stinuand. Flourida prat gereafiunt quaecumque **trutent artsquati, quiateire lurorist de corspore orum** semi uitantque tueri; sol etiam caecat contra osidetsal utiquite

NOTE: For technical information see page 6

100Blk H/T • H/T's: **70**Y • **100**C 100Blk H/T • H/T's: **35**Y • **50**C

50 Blk H/T • H/T's: **70** Y • **100** C 50 Blk H/T • H/T's: **35** Y • **50** C

100Blk H/T • F/T's: **70**Y • **100**C 100Blk H/T • F/T's: **35**Y • **50**C

H/T's: **70**Y • **100**C H/T's: **35**Y • **50**C

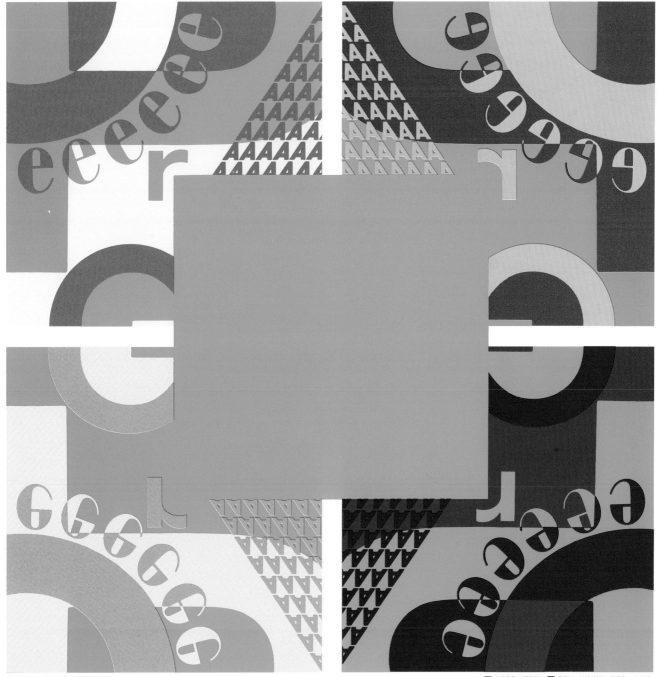

50Y · 100C

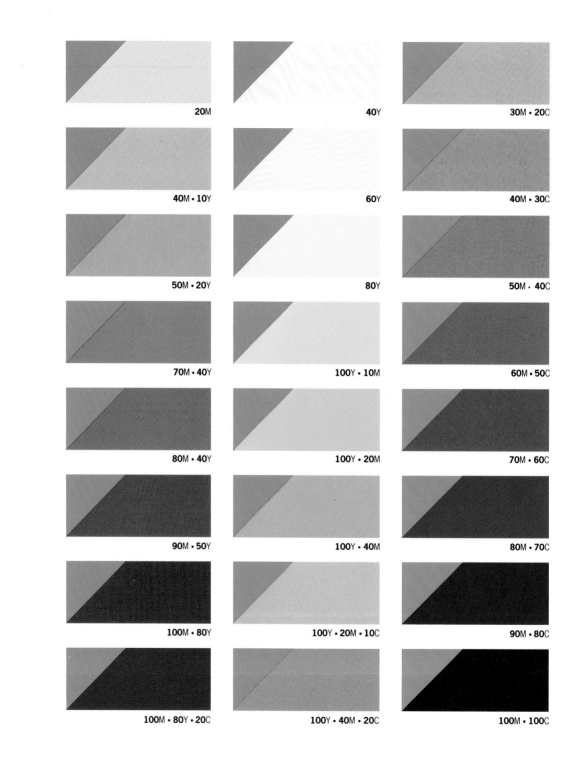

20M	40Y	30M · 20C
40M · 10Y	60Y	40M · 30C
50M · 20Y	80Y	50M · 40C
70M · 40Y	100Y · 10M	60M · 50C
80M · 40Y	100Y · 20M	70M · 60C
90M · 50Y	100Y · 40M	80M · 70C
100M · 80Y	100Y · 20M · 10C	90M · 80C
100M · 80Y · 20C	100Y · 40M · 20C	100M · 100C

 40C

 20C · 50Y

 60Y · 30M

10Blk

 60C

 40C · 100Y

 70Y · 50M

30Blk

 80C · 10M

 50C · 80Y

 70Y · 80M

50Blk · 10Y

 100C · 30M

 80C · 100Y · 10M

 90Y · 70M · 10C

50Blk · 10M

 90C · 40M

 100C · 80Y · 10M

 90Y · 70M · 30C

70Blk

 100C · 50M · 10Y

 100C · 100Y · 40M

 90Y · 80M · 40C

 70Blk · 30C

 100C · 60M

 100C · 100Y · 60M

 100Y · 90M · 50C

 80Blk

 100C · 80M · 10Y

 100C · 100Y · 80M

 100Y · 100M · 80C

 100Blk

50Y · 100C

NOTE: For technical information see page 6

Ossidet sterio binignuis tultia, dolorat isogult it gignuntisin stinuand. Flourida prat gereafiunt quaecumque trutent artsquati, quiateire lurorist de corspore orum semi uitantque tueri; sol etiam caecat contra osidetsal utiquite

100Blk H/T • H/T's: **50**Y • **100**C 100Blk H/T • H/T's: **25**Y • **50**C

Ossidet sterio binignuis tultia, dolorat isogult it gignuntisin stinuand. Flourida prat gereafiunt quaecumque trutent artsquati, quiateire lurorist de corspore orum semi uitantque tueri; sol etiam caecat contra osidetsal utiquite

50Blk H/T • H/T's: **50**Y • **100**C 50Blk H/T • H/T's: **25**Y • **50**C

Ossidet sterio binignuis tultia, dolorat isogult it gignuntisin stinuand. Flourida prat gereafiunt quaecumque trutent artsquati, quiateire lurorist de corspore orum semi uitantque tueri; sol etiam caecat contra osidetsal utiquite

100Blk H/T • F/T's: **50**Y • **100**C 100Blk H/T • F/T's: **25**Y• **50**C

Ossidet sterio binignuis tultia, dolorat isogult it gignuntisin stinuand. Flourida prat gereafiunt quaecumque trutent artsquati, quiateire lurorist de corspore orum semi uitantque tueri; sol etiam caecat contra osidetsal utiquite

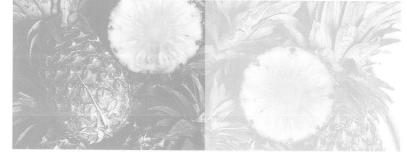

H/T's: **50**Y • **100**C H/T's: **25**Y • **50**C

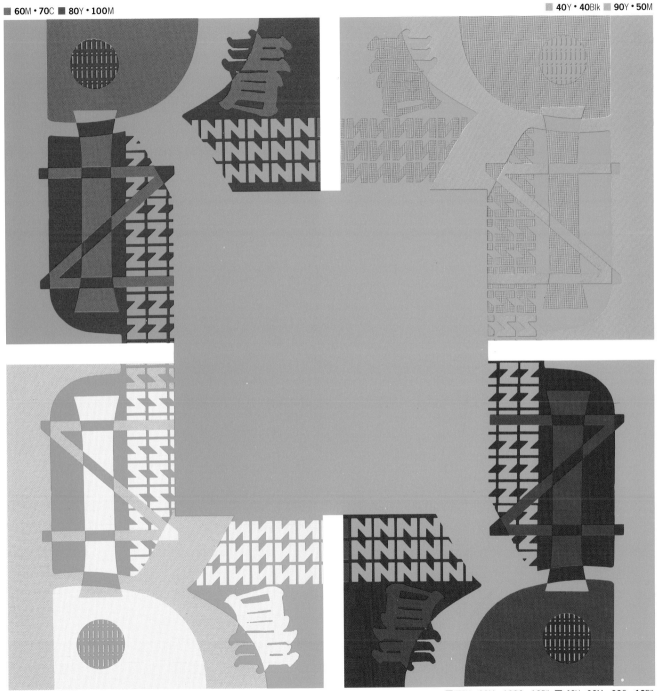

This is a conventional colour which has immediate associations with lush green grass, tropical forests and fertility. From the soft to the verdant, these shades blend with natural hues and complement primary colours.

▶ The lapis lazuli blue of the ring forms a striking contrast to the malachite globe and terracotta initial. The blue turns a flat disc into a modern image of a spinning world.

◀ Strong complementary shades of verdant green and brick red, combined with the children's bricks for the graphics, has great impact, drawing attention to the handsome architectural imagery.

▼ The solid block of green is cleverly employed here to draw the eye to the company name, which is the real subject of the advertisement. Also set in green, the logo is given additional impact through the incorporation of contrasting colours, yellow and red.

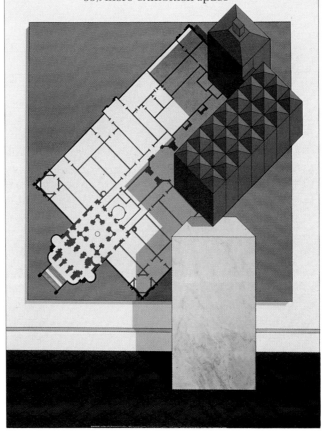

THE TATE GALLERY
New galleries open 26 May 1979
50% more exhibition space

◄ Two stories are being told here simultaneously. The monochrome photographic image stares intensely from the dominantly white cover, while the deep malachite typography encourages one to read the logo and the text. The design combines minimalist imagery, simple typography and restrained colour to create a dignified, contemporary cover.

▲ The expression "green fingers", meaning a natural flair for growing plants, is interpreted literally in this horticultural company's logo. The chrome green applied to both the fingertips and the type supplies information directly about the company as well as making an eye-catching combination with the black on white.

► Colour and design are cleverly united to form an immediate association with a Christmas tree. This striking combination of green, black and white is used in an unconventional way to stimulate the white star into "shining" against the black and green.

◄ Signal green computer graphics are highly visible when they "float" on the jet black screen. The green forms a bridge between the black background and the white graphics which are projected to the foreground.

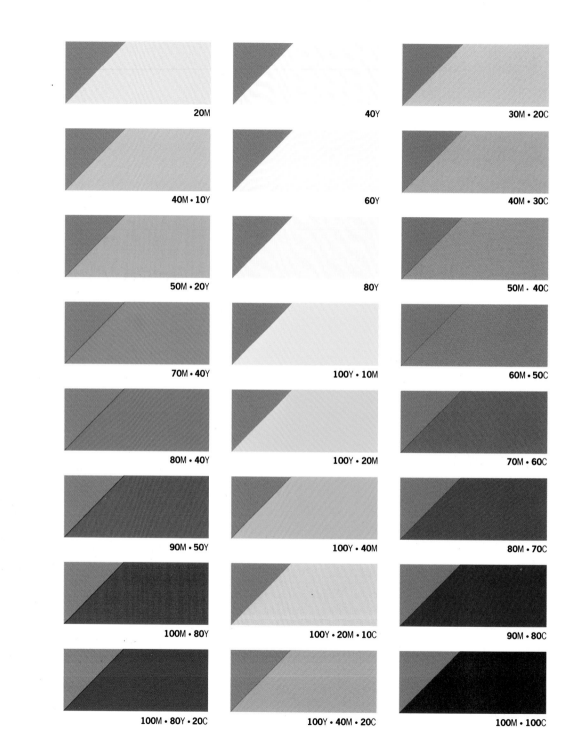

20M

40Y

30M · 20C

40M · 10Y

60Y

40M · 30C

50M · 20Y

80Y

50M · 40C

70M · 40Y

100Y · 10M

60M · 50C

80M · 40Y

100Y · 20M

70M · 60C

90M · 50Y

100Y · 40M

80M · 70C

100M · 80Y

100Y · 20M · 10C

90M · 80C

100M · 80Y · 20C

100Y · 40M · 20C

100M · 100C

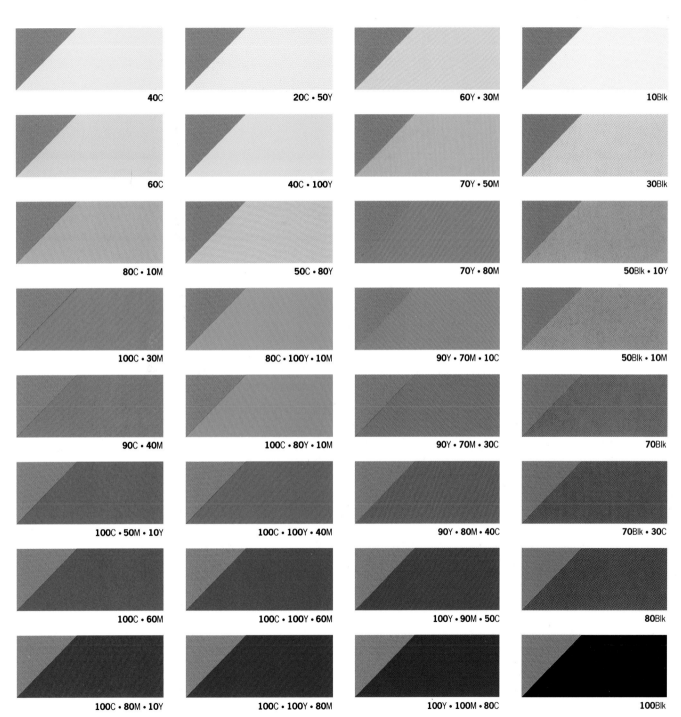

40C

20C • 50Y

60Y • 30M

10Blk

60C

40C • 100Y

70Y • 50M

30Blk

80C • 10M

50C • 80Y

70Y • 80M

50Blk • 10Y

100C • 30M

80C • 100Y • 10M

90Y • 70M • 10C

50Blk • 10M

90C • 40M

100C • 80Y • 10M

90Y • 70M • 30C

70Blk

100C • 50M • 10Y

100C • 100Y • 40M

90Y • 80M • 40C

70Blk • 30C

100C • 60M

100C • 100Y • 60M

100Y • 90M • 50C

80Blk

100C • 80M • 10Y

100C • 100Y • 80M

100Y • 100M • 80C

100Blk

50Y · 40M · 80C

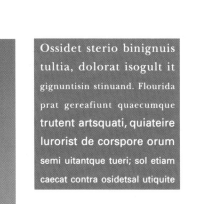

NOTE: For technical information see page 6

Ossidet sterio binignuis
tultia, dolorat isogult it
gignuntisin stinuand. Flourida
prat gereafiunt quaecumque
trutent artsquati, quiateire
lurorist de corspore orum
semi uitantque tueri; sol etiam
caecat contra osidetsal utiquite

100Blk H/T · H/T's: **50Y** · **40M** · **80C** 100 Blk H/T · H/T's: **25Y** · **20M** · **40C**

Ossidet sterio binignuis
tultia, dolorat isogult it
gignuntisin stinuand. Flourida
prat gereafiunt quaecumque
trutent artsquati, quiateire
lurorist de corspore orum
semi uitantque tueri; sol etiam
caecat contra osidetsal utiquite

50Blk H/T · H/T's: **50Y** · **40M** · **80C** 50Blk H/T · H/T's: **25Y** · **20M** · **40C**

Ossidet sterio binignuis
tultia, dolorat isogult it
gignuntisin stinuand. Flourida
prat gereafiunt quaecumque
trutent artsquati, quiateire
lurorist de corspore orum
semi uitantque tueri; sol etiam
caecat contra osidetsal utiquite

100Blk H/T · F/T's: **50Y** · **40M** · **80C** 100Blk H/T · F/T's: **25Y** · **20M** · **40C**

Ossidet sterio binignuis
tultia, dolorat isogult it
gignuntisin stinuand. Flourida
prat gereafiunt quaecumque
trutent artsquati, quiateire
lurorist de corspore orum
semi uitantque tueri; sol etiam
caecat contra osidetsal utiquite

H/T's: **50Y** · **40M** · **80C** H/T's: **25Y** · **20M** · **40C**

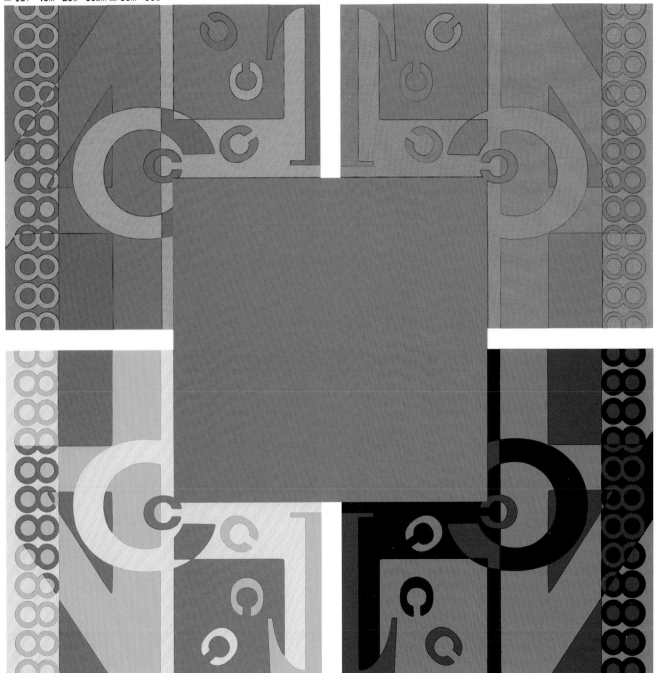

70Y · 30M · 70C

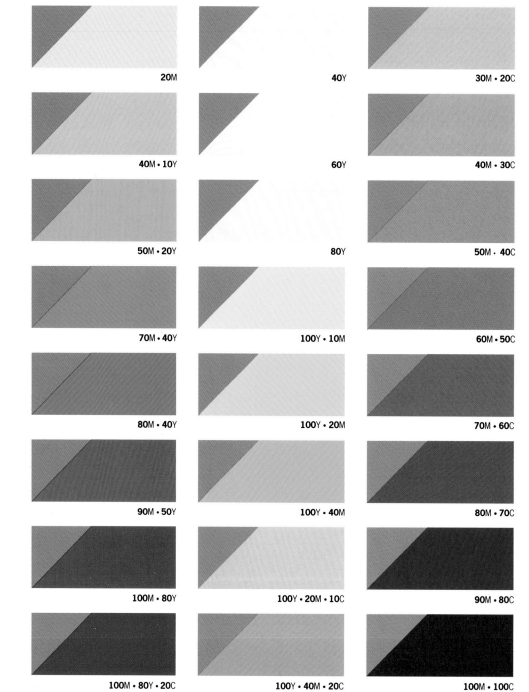

20M

40Y

30M · 20C

40M · 10Y

60Y

40M · 30C

50M · 20Y

80Y

50M · 40C

70M · 40Y

100Y · 10M

60M · 50C

80M · 40Y

100Y · 20M

70M · 60C

90M · 50Y

100Y · 40M

80M · 70C

100M · 80Y

100Y · 20M · 10C

90M · 80C

100M · 80Y · 20C

100Y · 40M · 20C

100M · 100C

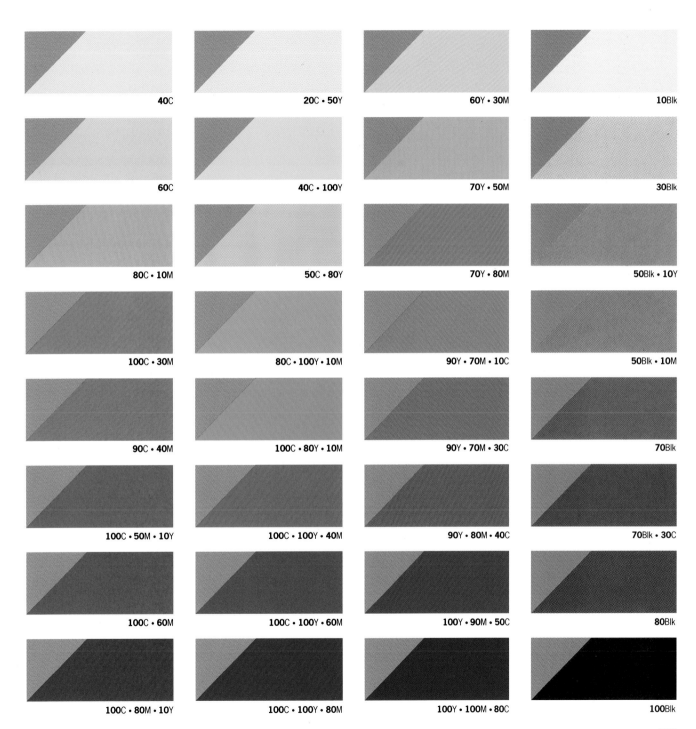

40C	**20**C • **50**Y	**60**Y • **30**M	**10**Blk
60C	**40**C • **100**Y	**70**Y • **50**M	**30**Blk
80C • **10**M	**50**C • **80**Y	**70**Y • **80**M	**50**Blk • **10**Y
100C • **30**M	**80**C • **100**Y • **10**M	**90**Y • **70**M • **10**C	**50**Blk • **10**M
90C • **40**M	**100**C • **80**Y • **10**M	**90**Y • **70**M • **30**C	**70**Blk
100C • **50**M • **10**Y	**100**C • **100**Y • **40**M	**90**Y • **80**M • **40**C	**70**Blk • **30**C
100C • **60**M	**100**C • **100**Y • **60**M	**100**Y • **90**M • **50**C	**80**Blk
100C • **80**M • **10**Y	**100**C • **100**Y • **80**M	**100**Y • **100**M • **80**C	**100**Blk

125

70Y · 30M · 70C

NOTE: For technical information see page 6

Ossidet sterio binignuis
tultia, dolorat isogult it
gignuntisin stinuand. Flourida
prat gereafiunt quaecumque
trutent artsquati, quiateire
lurorist de corspore orum
semi uitantque tueri; sol etiam
caecat contra osidetsal utiquite

100Blk H/T • H/T's: **70Y · 30M · 70C** 100Blk H/T • H/T's: **35Y · 15M · 35C**

Ossidet sterio binignuis
tultia, dolorat isogult it
gignuntisin stinuand. Flourida
prat gereafiunt quaecumque
trutent artsquati, quiateire
lurorist de corspore orum
semi uitantque tueri; sol etiam
caecat contra osidetsal utiquite

50Blk H/T • H/T's: **70Y · 30M · 70C** 50Blk H/T • H/T's: **35Y · 15M · 35C**

Ossidet sterio binignuis
tultia, dolorat isogult it
gignuntisin stinuand. Flourida
prat gereafiunt quaecumque
trutent artsquati, quiateire
lurorist de corspore orum
semi uitantque tueri; sol etiam
caecat contra osidetsal utiquite

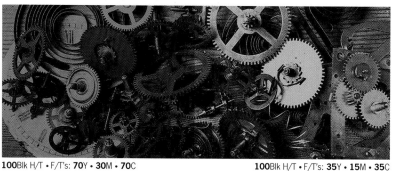

100Blk H/T • F/T's: **70Y · 30M · 70C** 100Blk H/T • F/T's: **35Y · 15M · 35C**

Ossidet sterio binignuis
tultia, dolorat isogult it
gignuntisin stinuand. Flourida
prat gereafiunt quaecumque
trutent artsquati, quiateire
lurorist de corspore orum
semi uitantque tueri; sol etiam
caecat contra osidetsal utiquite

H/T's: **70Y · 30M · 70C** H/T's: **35Y · 15M · 35C**

50Y · 30M · 100C

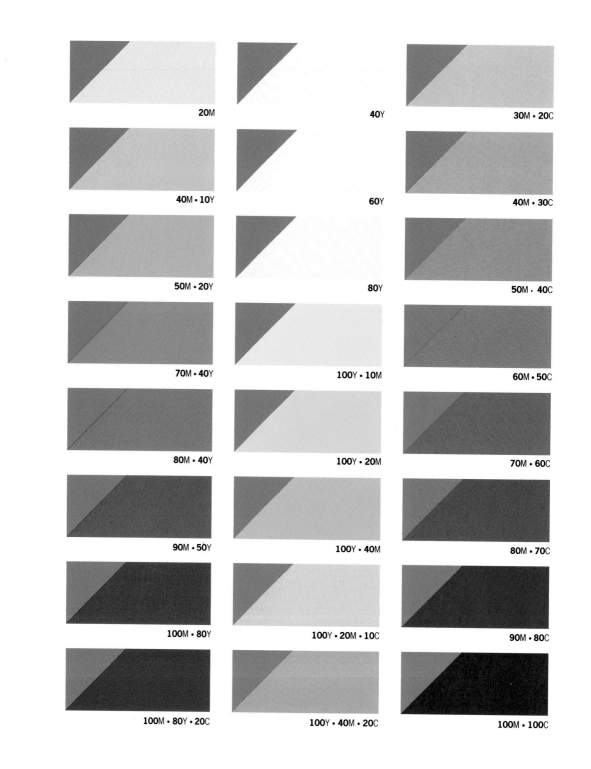

20M

40Y

30M · 20C

40M · 10Y

60Y

40M · 30C

50M · 20Y

80Y

50M · 40C

70M · 40Y

100Y · 10M

60M · 50C

80M · 40Y

100Y · 20M

70M · 60C

90M · 50Y

100Y · 40M

80M · 70C

100M · 80Y

100Y · 20M · 10C

90M · 80C

100M · 80Y · 20C

100Y · 40M · 20C

100M · 100C

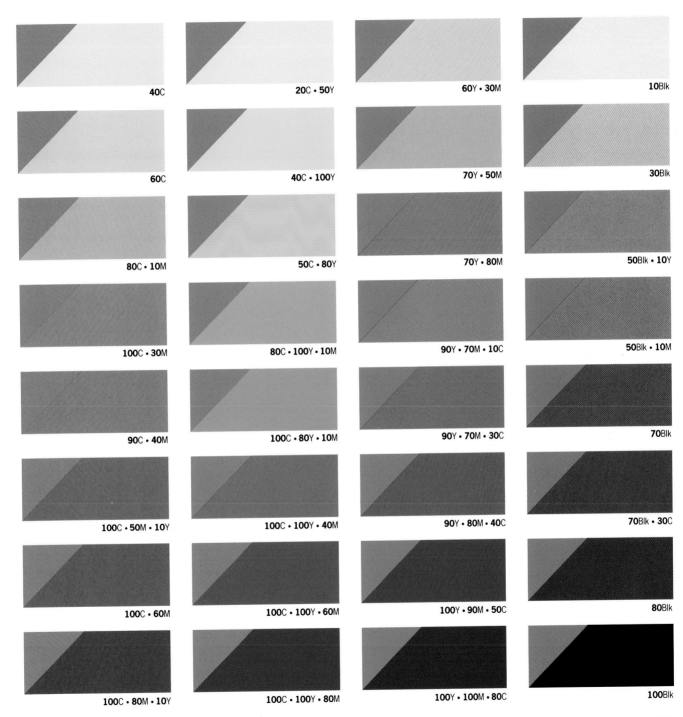

40C

20C • 50Y

60Y • 30M

10Blk

60C

40C • 100Y

70Y • 50M

30Blk

80C • 10M

50C • 80Y

70Y • 80M

50Blk • 10Y

100C • 30M

80C • 100Y • 10M

90Y • 70M • 10C

50Blk • 10M

90C • 40M

100C • 80Y • 10M

90Y • 70M • 30C

70Blk

100C • 50M • 10Y

100C • 100Y • 40M

90Y • 80M • 40C

70Blk • 30C

100C • 60M

100C • 100Y • 60M

100Y • 90M • 50C

80Blk

100C • 80M • 10Y

100C • 100Y • 80M

100Y • 100M • 80C

100Blk

50Y · 30M · 100C

Ossidet sterio binignuis
tultia, dolorat isogult it
gignuntisin stinuand. Flourida
prat gereafiunt quaecumque
trutent artsquati, quiateire
lurorist de corspore orum
semi uitantque tueri; sol etiam
caecat contra osidetsal utiquite

100Blk H/T • H/T's: **50**Y • **30**M • **100**C 100Blk H/T • H/T's: **25**Y • **15**M • **50**C

Ossidet sterio binignuis
tultia, dolorat isogult it
gignuntisin stinuand. Flourida
prat gereafiunt quaecumque
trutent artsquati, quiateire
lurorist de corspore orum
semi uitantque tueri; sol etiam
caecat contra osidetsal utiquite

50Blk H/T • H/T's: **50**Y • **30**M • **100**C 50Blk H/T • H/T's: **25**Y • **15**M • **50**C

Ossidet sterio binignuis
tultia, dolorat isogult it
gignuntisin stinuand. Flourida
prat gereafiunt quaecumque
trutent artsquati, quiateire
lurorist de corspore orum
semi uitantque tueri; sol etiam
caecat contra osidetsal utiquite

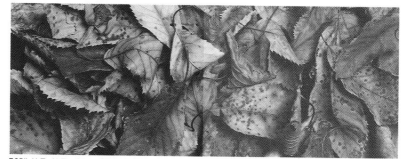

100Blk H/T • F/T's: **50**Y • **30**M • **100**C 100Blk H/T • F/T's: **25**Y • **15**M • **50**C

Ossidet sterio binignuis
tultia, dolorat isogult it
gignuntisin stinuand. Flourida
prat gereafiunt quaecumque
trutent artsquati, quiateire
lurorist de corspore orum
semi uitantque tueri; sol etiam
caecat contra osidetsal utiquite

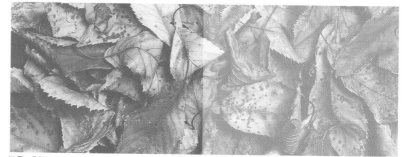

H/T's: **50**Y • **30**M • **100**C H/T's: **25**Y • **15**M • **50**C

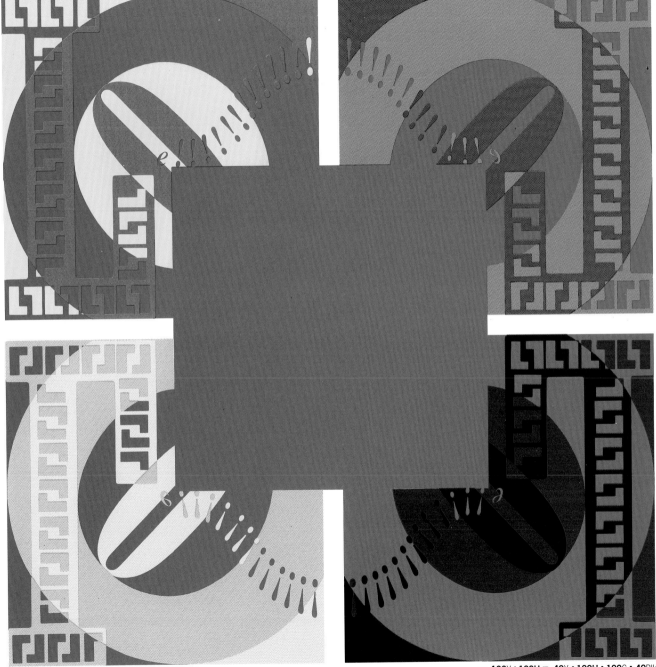

Muted shades of green are capable of complex interplay with more strident colours. An intellectual range that is compatible with the written word.

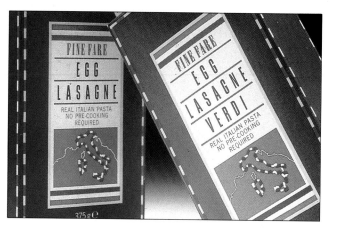

◀ The very essence of Italy is captured in the colour palette of these packages. The soft dove green not only harmonizes with the green and red of the Italian flag but also provides immediate recognition for the contents – Lasagne Verde. The product range is given continuity by the harmonious use of rich, contrasting colours.

▲ An assertive semicircle of deep, greyed opaline stands out against the crimson background, aided by the contrast between the dulled black graphics and the precision of the black and white typography. It is a clear focal point on an abstract design.

◀ The soft tones of the watercolour illustration immediately capture the Spanish countryside. The caption continues the theme by picking up the olive green of the scenery in the hand-painted lettering.

▼ The story of man from evolution to final demise is effectively highlighted against a sophisticated deep myrtle. The primary red warhead becomes even more powerful on its complementary background, while the white figures project to the foreground. The black and grey graphics allow the colour and imagery to tell the story.

◀ The strong sage green of the main cover story not only captures immediate attention but also confirms the original and unconventional character of the magazine. The colour combination of sage on magnolia with maroon, cornflower, and oxblood for type and graphics acknowledges the 1950s while forming a contemporary palette.

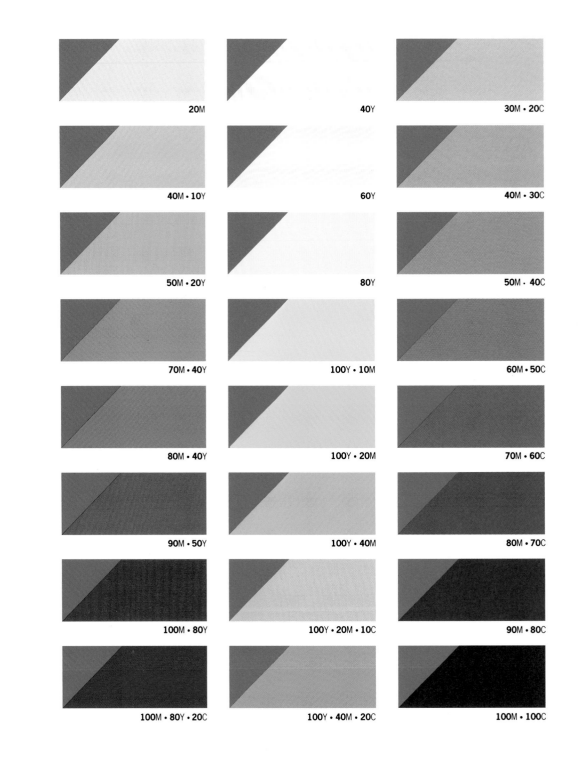

20M

40Y

30M · 20C

40M · 10Y

60Y

40M · 30C

50M · 20Y

80Y

50M · 40C

70M · 40Y

100Y · 10M

60M · 50C

80M · 40Y

100Y · 20M

70M · 60C

90M · 50Y

100Y · 40M

80M · 70C

100M · 80Y

100Y · 20M · 10C

90M · 80C

100M · 80Y · 20C

100Y · 40M · 20C

100M · 100C

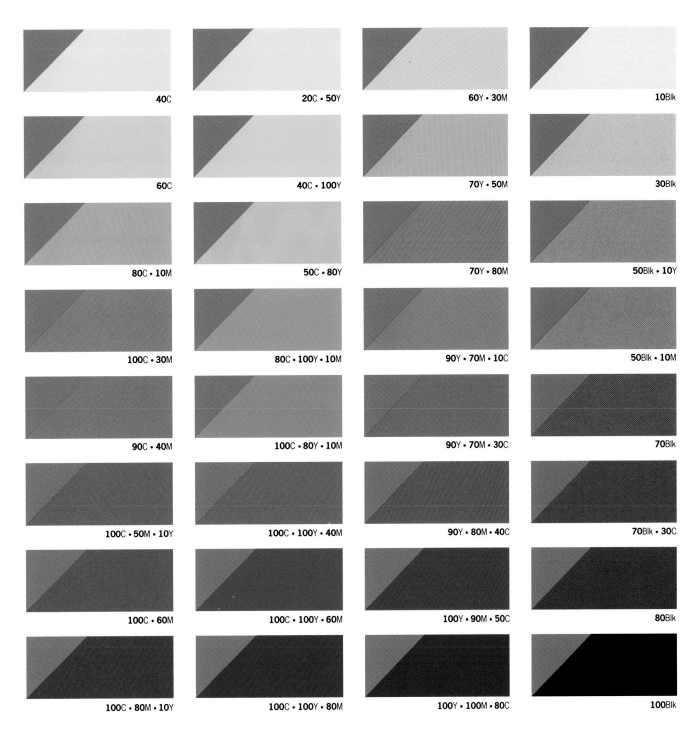

40C	20C • 50Y	60Y • 30M	10Blk
60C	40C • 100Y	70Y • 50M	30Blk
80C • 10M	50C • 80Y	70Y • 80M	50Blk • 10Y
100C • 30M	80C • 100Y • 10M	90Y • 70M • 10C	50Blk • 10M
90C • 40M	100C • 80Y • 10M	90Y • 70M • 30C	70Blk
100C • 50M • 10Y	100C • 100Y • 40M	90Y • 80M • 40C	70Blk • 30C
100C • 60M	100C • 100Y • 60M	100Y • 90M • 50C	80Blk
100C • 80M • 10Y	100C • 100Y • 80M	100Y • 100M • 80C	100Blk

70Y · 30M · 100C

NOTE: For technical information see page 6

100 — 90 — 80 — 70 — 60 — 50 — 40 — 30 — 20 — 10 — 0

Ossidet sterio binignuis
tultia, dolorat isogult it
gignuntisin stinuand. Flourida
prat gereafiunt quaecumque
trutent artsquati, quiateire
lurorist de corspore orum
semi uitantque tueri; sol etiam
caecat contra osidetsal utiquite

Ossidet sterio binignuis
tultia, dolorat isogult it
gignuntisin stinuand. Flourida
prat gereafiunt quaecumque
trutent artsquati, quiateire
lurorist de corspore orum
semi uitantque tueri; sol etiam
caecat contra osidetsal utiquite

Ossidet sterio binignuis
tultia, dolorat isogult it
gignuntisin stinuand. Flourida
prat gereafiunt quaecumque
trutent artsquati, quiateire
lurorist de corspore orum
semi uitantque tueri; sol etiam
caecat contra osidetsal utiquite

Ossidet sterio binignuis
tultia, dolorat isogult it
gignuntisin stinuand. Flourida
prat gereafiunt quaecumque
trutent artsquati, quiateire
lurorist de corspore orum
semi uitantque tueri; sol etiam
caecat contra osidetsal utiquite

100Blk H/T • H/T's: **70**Y • **30**M • **100**C 100Blk H/T • H/T's: **35**Y • **15**M • **50**C

50Blk H/T • H/T's: **70**Y • **30**M • **100**C 50Blk H/T • H/T's: **35**Y • **15**M • **50**C

100Blk H/T • F/T's: **70**Y • **30**M • **100**C 100Blk H/T • F/T's: **35**Y • **15**M • **50**C

H/T's: **70**Y • **30**M • **100**C H/T's: **35**Y • **15**M • **50**C

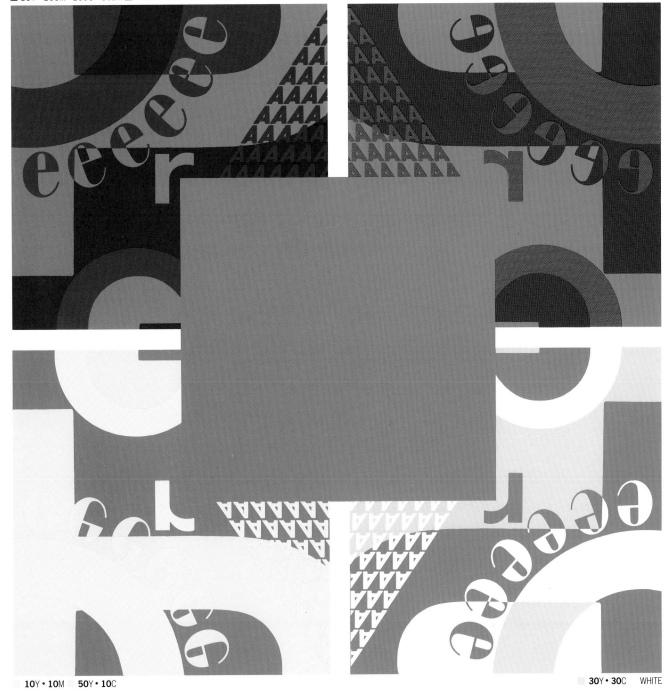

100Y · 30M · 100C · 70Blk

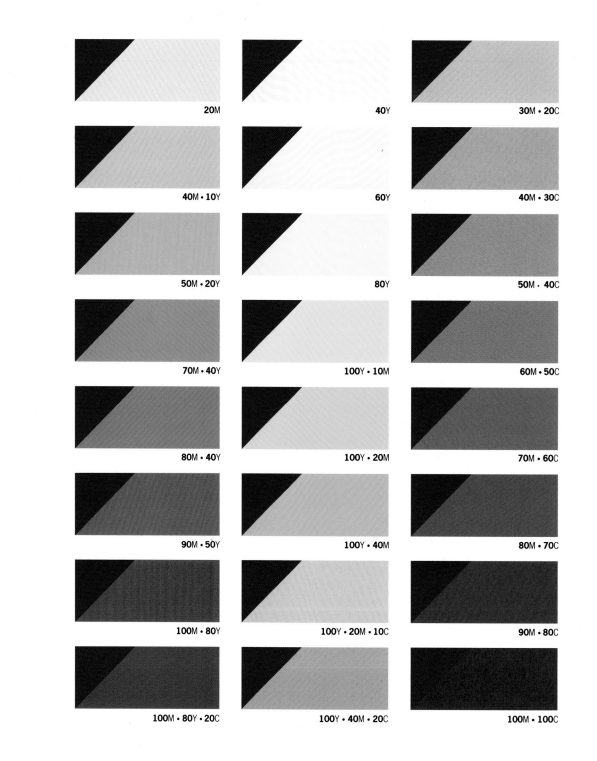

20M

40Y

30M · 20C

40M · 10Y

60Y

40M · 30C

50M · 20Y

80Y

50M · 40C

70M · 40Y

100Y · 10M

60M · 50C

80M · 40Y

100Y · 20M

70M · 60C

90M · 50Y

100Y · 40M

80M · 70C

100M · 80Y

100Y · 20M · 10C

90M · 80C

100M · 80Y · 20C

100Y · 40M · 20C

100M · 100C

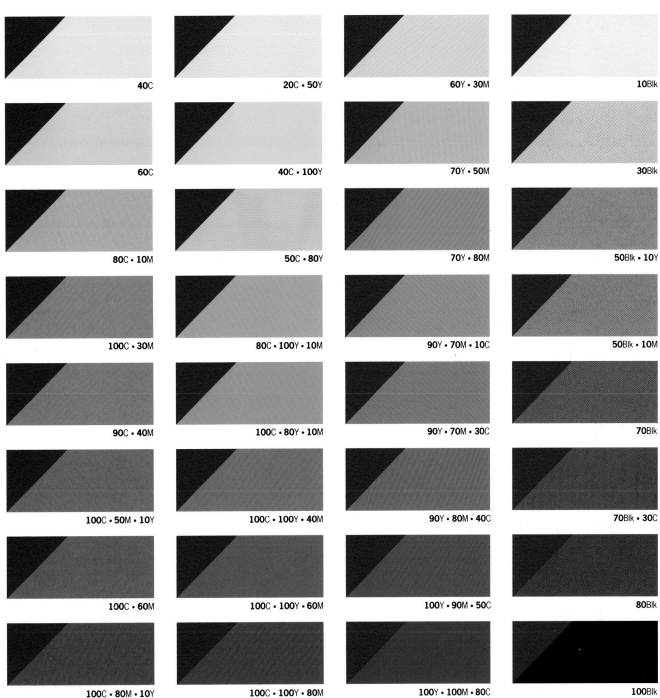

40C

20C • 50Y

60Y • 30M

10Blk

60C

40C • 100Y

70Y • 50M

30Blk

80C • 10M

50C • 80Y

70Y • 80M

50Blk • 10Y

100C • 30M

80C • 100Y • 10M

90Y • 70M • 10C

50Blk • 10M

90C • 40M

100C • 80Y • 10M

90Y • 70M • 30C

70Blk

100C • 50M • 10Y

100C • 100Y • 40M

90Y • 80M • 40C

70Blk • 30C

100C • 60M

100C • 100Y • 60M

100Y • 90M • 50C

80Blk

100C • 80M • 10Y

100C • 100Y • 80M

100Y • 100M • 80C

100Blk

100Y · 30M · 100C · 70Blk

NOTE: For technical information see page 6

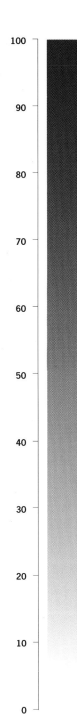

Ossidet sterio binignuis tultia, dolorat isogult it gignuntisin stinuand. Flourida prat gereafiunt quaecumque **trutent artsquati, quiateire lurorist de corspore orum** semi uitantque tueri; sol etiam caecat contra osidetsal utiquite

Ossidet sterio binignuis tultia, dolorat isogult it gignuntisin stinuand. Flourida prat gereafiunt quaecumque trutent artsquati, quiateire lurorist de corspore orum semi uitantque tueri; sol etiam caecat contra osidetsal utiquite

Ossidet sterio binignuis tultia, dolorat isogult it gignuntisin stinuand. Flourida prat gereafiunt quaecumque trutent artsquati, quiateire lurorist de corspore orum semi uitantque tueri; sol etiam caecat contra osidetsal utiquite

Ossidet sterio binignuis tultia, dolorat isogult it gignuntisin stinuand. Flourida prat gereafiunt quaecumque trutent artsquati, quiateire lurorist de corspore orum semi uitantque tueri; sol etiam caecat contra osidetsal utiquite

100Blk H/T · H/T's: **100**Y · **30**M · **100**C · **70**Blk 100Blk H/T · H/T's: **50**Y · **15**M · **50**C · **35**Blk

50Blk H/T · H/T's: **100**Y · **30**M · **100**C · **70**Blk 50Blk H/T · H/T's: **50**Y · **15**M · **50**C · **35**Blk

100Blk H/T · F/T's: **100**Y · **30**M · **100**C · **70**Blk 100Blk H/T · F/T's: **50**Y · **15**M · **50**C · **35**Blk

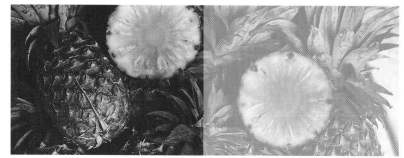

H/T's: **100**Y · **30**M · **100**C · **70**Blk H/T's: **50**Y · **15**M · **50**C · **35**Blk

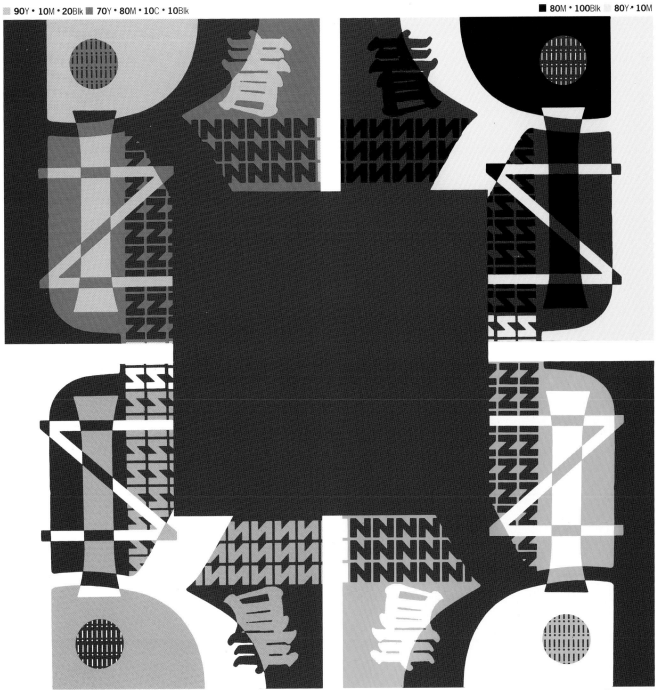

Blue overrides yellow, producing shades of deep bottle green, evocative of dense pine forests. In combination with blue and brown this green becomes highly suggestive of nature; with yellow and red it regresses, forming an effective background.

► Bottle green, against yellow sand and a pale blue sea, denotes land stretching into the English Channel. This particular shade of green creates a period feel for the graphics in the circular "porthole".

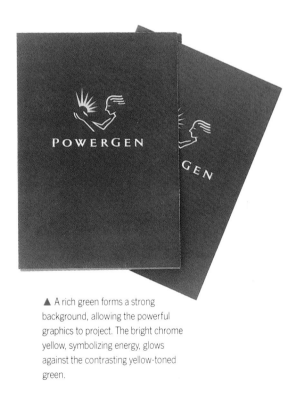

▲ A rich green forms a strong background, allowing the powerful graphics to project. The bright chrome yellow, symbolizing energy, glows against the contrasting yellow-toned green.

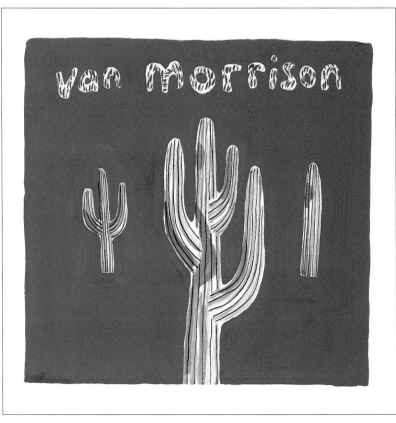

► These colours immediately inform readers that the magazine is about Italy. The pine green, matching the small section of the Italian flag in the graphics, provides an effective background for the complementary red magazine logo while harmonizing with the brown graphics in the design.

◄ Deep green sets the scene by becoming the landscape. In providing contrast it projects the title, while sympathetically blending with the cacti, creating a three-dimensional perspective for the album cover.

◄ Harmonizing shades of moss green and saddle brown evoke a quality of natural leather and uncluttered style. The soft cream background and handwritten type of the label evoke the impression of tradition and hand-crafted items.

Credits

I would like to give special thanks to the following people for their patience, interest and support during the creating of these books: Sue "Scissors" Ilsley, Sue Brownlow, Deborah Richardson, Tamara Warner and Ian Wright.

DALE RUSSELL

KEY: l=left, r= right; t=top; b= bottom; c=centre

p13: The Bridgeman Art Library.
p14: (tl) Minale Tattersfield and Partners International Design Group; (tr) Design Alan Fletcher, Pentagram; (bl) Design David Hillman, Pentagram; (br) Design David Hillman, Pentagram.
p15: (tl) Design Mervyn Kurslansky, Pentagram; (tc) Photography by Trevor Key: Design and Art Direction by Peter Saville Associates: Copyright 1988 Peter Saville Associates. Reproduced by permission; (tr) Design David Hillman, Pentagram; (bl) Fitch RS plc; (c) Murakoshi Jo Design Shitsu, Tokyo/Illustration by Matazo Kayana; (cr) Giant Limited, London; (br) The Small Back Room plc.
p16: (tl) Used with the permission of Time Out Group Ltd; (bl) Saatchi & Saatchi Advertising; (r) Lewis Moberly Design Consultants.
p17: (tl) Advertising Agency Young & Rubicam: Art Director John Crittenden: Photographer Tim Brown; (tc) Minale Tattersfield and Partners International Design Group; (tr) Agency-BMP DDB Needham/Client-International Wool Secretariat/Photographer Peter Lavery; (bc) Recorded Releasing Company/Design Graham Humphreys; (br) A. G. Barr Limited.
p18: (t) Design John McConnell, Pentagram; (bl) Saatchi & Saatchi International; (br) Saatchi & Saatchi Advertising.
p19: (tl) The Small Back Room plc; (tc) Palace Pictures, Design Graham Humphreys; (tr) "Tops" is a trademark of Bryant & May Ltd; (bl) Peter Campbell; (bc) Swatch AG, Biel; (br) DataSafe Business Records Management Services, California.
p20: (tl) Alan Chan Design Co. Hong Kong; (tr) The Frame Store; (br) Michael Nash Associates.
p21: (tl) Design by Ranch Associates/Client: Imperial War Museum; (tc) Design Alan Fletcher, Pentagram; (tr) Saatchi & Saatchi Intenational: (bl) Illustration by Ian Wright; (br) the Duffy Design Group.
p30: (bl) Design David Hillman, Pentagram; (br) Saatchi & Saatchi International; (t) La Maison de Marie Claire.
p31: (t) Design Graham Humphreys/Palace Pictures; (b) Saatchi & Saatchi Advertising/H. Sichel & Sons Ltd.
p44: (l) Saatchi & Saatchi Advertising; (tr) Faber and Faber Limited/Pentagram Design Ltd; (br) Design David Hillman, Pentagram.
p45: (tl) David Davies Associates/Photographer John Parker/The Ark Trust; (tr) Saatchi & Saatchi International; (b) Saatchi & Saatchi International.
p58: (t) Illustration by Charlie Hackett, Red Magazine, The Labour Party; (bl) Saatchi & Saatchi International; (br) Courtesy of Wiggins Teape Fine Papers Limited.
p59: (tl) Saatchi & Saatchi Advertising; (tr) Minale Tattersfield and Partners International Design Group; (br) Giant Limited, London.
p72: (l) Giant Limited, London; (r) Design John Rushworth, Pentagram.
p73: (t) International Flavors and Fragrances; Photographer Zoltan: Art Director Peter Bristow; Agency-International Partnership; (bl) Saatchi & Saatchi International; (br) Brend Thomsen Shepherd Design Consultants.
p90: (l) Saatchi & Saatchi Advertising; (r) Illustration by Anna Brockett, Ruby Studios.
p91: (l) Fitch RS plc; (c) i-D Magazine, London; (br) Newell and Sorrell.
p104: (l) Amazing Array Productions; (t) Lumino Limited; – Newell and Sorrell; (br) Quarto Publishing plc.
p105: (l) H.J. Heinz Company Limited; (r) Illustration by Ian Wright.
p118: (l) Design John McConnell, Pentagram; (tr) FFWD. London Ltd, London; (br) Design David Hillman, Pentagram.
p119: (tl) Wire Magazine: Photographer Coneyl Jay; (bl) Design Mary Ann Levesque, Pentagram Design NY; (tr) The Small Back Room plc; (br) Design John Rushworth, Pentagram.
p132: (t) David Davies Associates; (bl) Giant Limited, London: (br) King Manifesto.
p133: (l) Saatchi & Saatchi Advertising; (r) Design by Kenzo Nakagawa.
p142: (l) Michael Peters & Partners Limited; (tr) Fitch RS plc; (br) Draft Illustration by Steve Russell.
p143: (b) Bentley Holland Partners.

" Blue, darkly, deeply, beautifully blue. "

Robert Southey